CW00544752

JOHN HENRY SPREE'S NOTTINGHAMSHIRE

ALAN SPREE

AMBERLEY

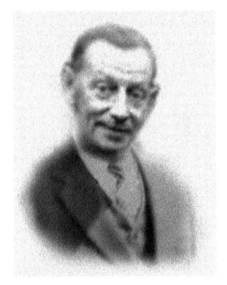

John Henry Spree, 1869–1932.

First published 2018

Amberley Publishing
The Hill, Stroud
Gloucestershire, GL5 4EP

www.amberley-books.com

British Library Cataloguing in Publication Data.
A catalogue record for this book is available from the British Library.

ISBN 978 1 4456 8027 9 (print)
ISBN 978 1 4456 8028 6 (ebook)

Origination by Amberley Publishing.
Printed in the UK.

Contents

Acknowledgements

The author would like to thank the following individuals and organisations for their cooperation in producing this book:

Picture the Past
The libraries and museums of Derby, Derbyshire, Nottingham and Nottinghamshire have many thousands of historic photographs in their collections. Using Lottery funding, the local city and county councils have put together the Picture the Past website to view their vast collections. It includes a number of Spree postcards, some of which are not included here. Images used with permission from Picture the Past in this book are individually credited on the captions to them. www.picturethepast.org.uk

Woodborough Heritage
A non-profit website set up to provide information about the heritage of Woodborough. It is an excellent site and features a number of Spree postcards in many digital photo albums. myweb. tiscali.co.uk/woodboroughheritage

Lenton Times
The magazine of the Lenton Local History Society was formed in 1973. It includes all manner of illustrated articles focussing on the history of this particular part of Nottingham. It also has its own website that includes a section on John Henry Spree's postcards. *Lenton Times* Nos 32 and 34 also featured articles on John Henry Spree. A number of additional Spree postcards that are not included here can be found on the *Lenton Times* website. The relevant address for this section of their website is www.lentontimes.co.uk/streets/spree_postcards.htm

Andrew P. Knighton
A postcard collector and author who has been a great help in compiling my collection of John Henry Spree postcards. He has also generously submitted over a thousand images of Nottinghamshire and Derbyshire for use on the Picture the Past website.

Mark Wingham
To the editor of *Picture Postcard Monthly* for his interest in my project and for publishing articles that have assisted in compiling my collection of John Henry Spree postcards. www. picturepostcardmagazine.co.uk

Introduction

I have compiled this book to give an insight into the history of a prolific postcard publisher, John Henry Spree, who published over 1,000 postcards – initially in East Sussex and then in the East Midlands. The book contains 220 images taken by the photographer in the period from 1915 – when he moved from Hastings to Nottingham – until his death in 1932. Each image has a brief accompanying caption.

In the summer of 1997 I was in Nottingham and was browsing through books in WHSmith on Lister Gate when I came across a booklet in the *Yesterday's Nottinghamshire* series entitled 'Wollaton' by David Ottewell. As I was born in that area I flicked through it and was surprised to find some postcards with the name 'J. Spree' on them. Being an unusual surname I assumed it was a relative, which proved to be true. I researched the family history and spoke to my father to find out more about 'J. Spree' and found that he was my great-grandfather, John Henry Spree. My father's memories of his grandfather gave me a fascinating insight into how life was lived in those days. I started to write down the memories that my father expressed to me and then added to them more detailed information gained during my family history research.

These discussions with my father brought up some of my early childhood memories of my grandad teaching me the basics of photography and how to develop and print photographs. Grandad Spree's darkroom had been set up by his father, John Henry Spree. As part of the learning process, my grandad used photographs taken by his father to teach me about composing the image, aperture sizes and shutter speeds. While developing and printing in the darkroom with my grandad I remember that there were boxes of photographs and negatives stored away in the corner. They were the complete photographic records of John Henry Spree, but at the time I was not aware of their significance.

At the time of writing, my search relating to Spree postcards has been ongoing for twenty years. My initial interest prompted by the 'Wollaton' booklet was just in collecting images, but later I started collecting original postcards as well. I started by writing to the publisher of the booklet who forwarded this to David Ottewell. David replied and kindly provided me with photocopies of his collection of Spree postcards. This collection of postcard images was added to my jottings on John Henry Spree, which was in effect the birth of this book.

As the Internet became more affordable and there was an exponential increase in the information available, it became my main tool in searching for Spree postcards. In particular, the launch of the website Picture the Past in the spring of 2003 was a milestone. Picture the Past is a Lottery-funded website that makes images available online from the libraries and museums of Derby, Derbyshire, Nottingham and Nottinghamshire. Also of significance was the July 1999 launch of eBay in the UK.

I regularly search the Internet for any Spree postcards that have been put up for sale or have been included in any article. I periodically 'Google' the name of a location where I know John Henry Spree has produced postcards and go through articles on family or local history sites, and very occasionally this will bring a result.

Identification of Spree Postcards and the Locations

Although it was easy to identify many of his postcards as they had the name 'Spree', 'J. Spree' or simply 'JS' in the early days, it soon became apparent that some were published with only the

location name. To try and identify those that did not have his name on them, I scanned the named postcards and made a chart of the capital and lower case letters used in his handwriting. I then used this to identify unnamed postcards by the comparison of the characteristic individual letters, numbers and words used on named Spree postcards with those that were not. An abbreviation of the county – such as Nottm, Notts or Derbys – appear on many postcards, but not always. Sometimes postcard numbers do not appear either, and, in rare instances, not even the location.

Some locations were obvious from the postcard and others had been identified on various websites, but I occasionally had to use Google Earth to 'walk' around the area to identify the exact location. Sometimes buildings were still standing or there were other identifying objects visible. Other means of determining the exact location included contacting parish councils or local history societies, who have been very helpful.

John Henry Spree Family History, 1869–1932

Great-grandad John Henry Spree was born in 1869 at No. 6 Railway Cottages in Canterbury. He was named John Henry after his father, but was commonly called Jack to avoid confusion.

John Henry Spree married Esther Jane Glazier on 30 November 1891 at the Parish Church of Westfield in Sussex. In 1899 the couple lived at No. 59 London Road, St Leonard's on Sea, and it was there that on 16 June his son (my grandad) Reginald John Spree was born. John Henry Spree began to produce picture postcards of the Hastings area from around 1904 while residing at London Road, Hastings, and employed as a railway signalman.

By 1911 the Spree family had moved to No. 13 Stainsby Street in St Leonards, near Hastings. Around this time John Henry Spree was still employed as a signalman on the British Rail Southern Region. He apparently was later sacked from this job for reasons that he never explained to the family.

John Henry Spree then took a job as a photographer at Judge's in Hastings, where he successfully worked for a number of years. It could be that he moved to be nearer his work, as he was now living with the family at No. 15 Silverlands Road in Hastings.

In 1915 the photography shop where he worked in Hastings closed down and John Henry was forced to look around for fresh employment. Somehow, despite his earlier sacking, he managed to get another job working on the railway – this time as a government inspector based in Nottingham.

His son, Reginald John Spree, had a job in Manfield's shoe shop in Hastings and after his parents moved to Nottingham he worked at one of their London branches, before getting a transfer up to Nottingham. He only stayed in the Nottingham shoe shop for a short time before being taken on at the Player's cigarette factory as a process worker.

After around five or six years working on the railway, John Henry Spree started his own business as a photographer and opened a shop in Willoughby Street, Lenton. The business was not successful and closed down after a couple of years. With the experience he had gained, however, he managed to get a job at another photographers, located on Parliament Street in Nottingham.

In 1921, Lillian May Parker, born 6 June 1902 in Bourneville near Birmingham, married Reginald John in Nottingham. They lived with John Henry and Esther Jane Spree at No. 44 Johnson Road in Lenton.

In September 1921, Lillian May became pregnant and the family, including great-grandad John Henry and great-grandma Esther Jane Spree, soon moved to No. 101 Danethorpe Vale, Sherwood, where my father, Victor John Spree, was born on 25 June 1922.

John Henry apparently continued to work at the photographers in Nottingham even though he was also producing and selling his own postcards of Nottinghamshire, Derbyshire, Lincolnshire and Leicestershire. John Henry had a motor car to travel around to take his photographs, which my father recollects as being a Morris Cowley Bullnose. This type of car appears in a number of his postcards and is presumably his.

John Henry used to have a darkroom in the attic where he would develop his photographs and experiment with different ways of developing. He used a sepia-toner for his postcards and also experimented with a green one, but the results with that were not suitable for publication. His fingers were apparently always stained with bromide, so it looked as though he was a heavy smoker.

John Henry Spree took many photographs of Nottingham as it developed. My father recalls seeing a number of photographs taken of the new Nottingham Council House during its construction in the mid- to late 1920s; however, I have unfortunately been unable to find one image of those photographs.

John Henry Spree suffered from high blood pressure, and on a number of occasions a doctor or nurse would visit to insert a tube into his arm to 'bleed' him into a container. The blood that was drawn off to 'reduce the pressure' was then disposed of in the toilet.

In 1929 the family moved to No. 165 Hawton Crescent, Wollaton Park, and Victor John was enrolled at the newly opened Harrow Road Junior School. The school badge was designed using one of the photographs that John Henry Spree had taken of the Wollaton Park gates.

It is not clear how many postcards John Henry Spree produced, but as many of his photographs are numbered this shows that there were over a thousand. How many of these were made into postcards is not known. It is clear from the distinctive writing style of the captions on the photographs that many of his photographs were also published as picture postcards by WHSmith & Sons of Nottingham.

Despite deterioration in his health, John Henry Spree continued to work as a photographer and also gained some extra income through the sale of his picture postcards. However, poor health eventually required John Henry to go into Bagthorpe Hospital, where he died in March 1932 at the age of sixty-three. He was buried at Beeston Cemetery in Section B-B8-88.

John Henry Spree Family History, 1932–2017

Esther Jane Spree (my great-grandma) continued to live with the family in Hawton Crescent until her death in April 1948 at the age of seventy-eight. Esther was buried next to her husband in Beeston Cemetery.

The Spree family decided to move from Nottingham to Portsmouth in 1959. My Grandad and Grandma Spree accompanied my mother, father, sister and I to the new location.

In 1963, while building a shed in my Grandad and Grandma Spree's house in Adair Road, Eastney, I was again acquainted with the boxes of photographs taken by Great-Grandad John Henry Spree, which had been added to by his son (my grandad) Reginald John Spree. We were talking about some of the places in Nottingham and Grandad brought out the photos to show me what the city used to look like.

Nine years after Grandad Spree died, and on a trip back to the UK in 1996 from Germany where I was working, my wife and I went round to his old house in Adair Road to see how his second wife was getting on, but found that she had died a few months earlier. Unfortunately, none of the Spree family had been notified. The next-door neighbour told us that on her death her son had come over from America, sold the house and had burnt or dumped all the rest.

A treasure trove of photographic history was apparently lost, but with time and effort, and the advent of the digital age, I have gradually made efforts to rebuild that photographic collection so that future generations will have a record of the work of John Henry Spree. This book is part of that process.

My sister, her husband and two daughters emigrated to Australia in 1972 and continue to live there. My mother and father emigrated to Australia in 1982 and died there in 2007 and 2002 respectively.

My wife and I have two sons and four grandchildren and we retired to Spain in 2006, which gave me the much-needed time to research and write this book.

Location of the Postcards Featured

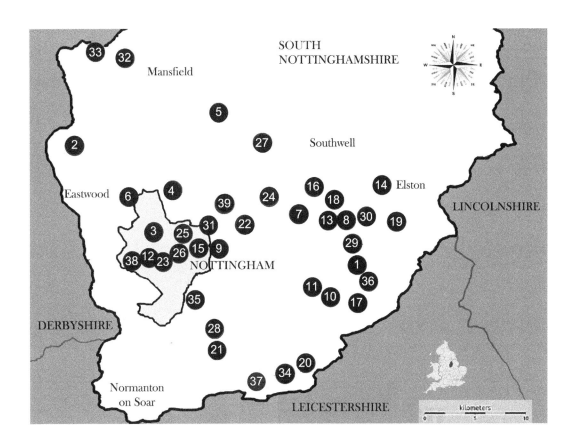

Key
1. Aslockton
A village 12 miles east of Nottingham and 2 miles east of Bingham on the north bank of the River Smite, opposite Whatton in the Vale.

2. Bagthorpe
Located 15 miles north-west of Nottingham. It is situated in a valley to the south of Selston and to the east of Jacksdale. The village has a rural atmosphere with a small stream running alongside the Lower Bagthorpe Road, the only through road.

3. Basford
A suburb in northern Nottingham and lies close to the River Leen, a tributary of the River Trent.

4. Bestwood
A village in the Gedling district. A small part of the village falls within the Ashfield District Council area. It is to the east of Hucknall and north of Bulwell. It is neighboured to the north by the village of Papplewick.

5. Blidworth
A small village approximately 5 miles east of Mansfield. Its history can be traced back to the tenth century, although many of the current houses were built in the first half of the twentieth century to provide housing for workers at Blidworth Colliery.

6. Bulwell
A large market town approximately 4.5 miles north-west of Nottingham city centre.

7. Burton Joyce
A large village and civil parish in the Gedling district. The village sits by the River Trent and nearby are Carlton, Bulcote, Stoke Bardolph and Lowdham.

8. Car Colston
A small village and civil parish in the Rushcliffe borough. The village is just off the old Fosse Way, north of Bingham and west of East Bridgford.

9. Carlton
A suburb to the east of the city of Nottingham in the borough of Gedling.

10. Cropwell Bishop
A village in the borough of Rushcliffe. The next village to the north is Cropwell Butler. Both villages form part of the Vale of Belvoir. The village has one of a select six creameries that produce Stilton cheese.

11. Cropwell Butler
A village in the borough of Rushcliffe. The next village to the south is Cropwell Bishop.

12. Dunkirk
A residential area of Nottingham located to the south-east of the University of Nottingham. It is in the electoral ward of Dunkirk and Lenton.

13. East Bridgford
A village east of the city of Nottingham in the Rushcliffe borough. East Bridgford lies on the southern bank of the River Trent, more or less opposite the village of Gunthorpe.

14. Gedling
A borough and part of the greater Nottingham metropolitan area, lying to the north-east of the city.

15. Elston
A small village and civil parish located to the south-west of Newark and a mile from the Fosse Way. The parish of Elston lies between the rivers Trent and Devon.

16. Gonalston
A small village to the north-east of Lowdham. It lies on a small river called the Dover Beck, which separates the village from Lowdham and flows south-east into the River Trent.

17. Granby
A small village in the Rushcliffe district of Nottinghamshire. It lies in the Vale of Belvoir.

18. Gunthorpe
A small village outside of Nottingham. Gunthorpe Bridge is the only bridge over the River Trent between Newark and Nottingham. Gunthorpe is in the Newark and Sherwood district.

19. Hawksworth
A village located 10 miles south of Newark-on-Trent. The Church of St Mary and All Saints in Hawksworth is Norman but was almost completely rebuilt in the nineteenth century.

20. Hickling
A village near Melton Mowbray in Leicestershire, but is in and on the southernmost border of Nottinghamshire. It is within the boundaries of Rushcliffe Borough Council.

21. Keyworth
A village and civil parish. It is located around 6 miles south-east of the centre of Nottingham. The village sits on a small broad hilltop around 200 feet above sea level.

22. Lambley
A small village near Nottingham. Lord Ralph Cromwell was born in the village in 1394. He became the Lord Treasurer of England to Henry VI and was responsible for submitting the first budget to Parliament.

23. Lenton
Lenton became part of Nottingham in 1877, when the then town's boundaries were enlarged.

24. Lowdham
Lowdham is a village between Nottingham and Southwell and is in the Newark and Sherwood district.

25. Mapperley
A residential and commercial area of north-east Nottingham. The area is bounded by Sherwood to the north-west, Thorneywood to the south and Gedling to the east.

26. Nottingham
Known for its links to the legend of Robin Hood and for its lacemaking, pharmaceutical, bicycle and tobacco industries. It was granted its city charter in 1897 as part of Queen Victoria's Diamond Jubilee celebrations.

27. Oxton
A village located 5 miles west of Southwell, 5 miles north of Lowdham, 10 miles north-east of Nottingham and 2 miles north-east of Calverton.

28. Plumtree
A village and civil parish in the borough of Rushcliffe. It is situated to the south-east of Nottingham between the villages of Tollerton and Keyworth.

29. Scarrington
A parish and village located 1.5 miles from Aslockton. Until 1945 it was also home of Little Lunnon, a group of around fourteen ancient mud and thatched cottages built at the edge of Scarrington, almost as a separate community.

30. Screveton
A parish and village in the Rushcliffe borough adjacent to Kneeton, Flintham, Hawksworth, Scarrington, Little Green and Car Colston.

31. Sherwood
A large residential area in the north of Nottingham, approximately 1.5 miles from the city centre.

32. Skegby
A small village in the Ashfield district located 2 miles west of Mansfield and 1 mile north of Sutton in Ashfield.

33. Teversal
A small village in the Ashfield district located 3 miles west of Mansfield, close to the Derbyshire border. Teversal was the home of the fictional Lady Chatterley in the novel *Lady Chatterley's Lover* by D. H. Lawrence.

34. Upper Broughton
Located in the Rushcliffe borough and on the edge of the picturesque Vale of Belvoir.

35. West Bridgford
A town in the Rushcliffe borough, immediately south of the city of Nottingham and separated by the River Trent. It forms a continuous urban area with Nottingham, however, effectively making it a suburb of the city.

36. Whatton
Located in the Rushcliffe borough. It lies in the Vale of Belvoir on the south bank of the River Smite, 12 miles east of Nottingham.

37. Willoughby on the Wolds
A small village on the border with Leicestershire. The nearest neighbouring villages are Wysall, Widmerpool, Wymeswold and Keyworth.

38. Wollaton
A suburb and former parish in the western part of Nottingham. It is home to Wollaton Hall with its museum, deer park, lake, walks and golf course.

39. Woodborough
A village located 7 miles north-east of Nottingham. Woodborough was a framework knitting village and some two-storey cottages with large ground-floor knitter's windows still remain.

The Postcard Collection

Aslockton

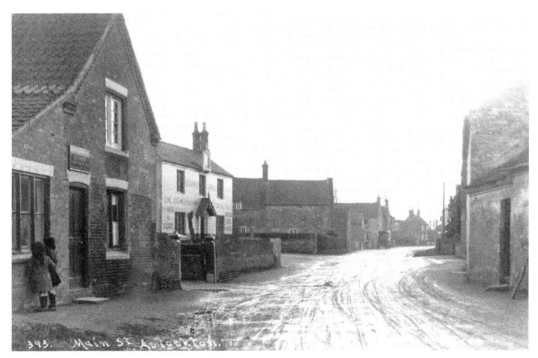

Aslockton's Main Street. Dr Thomas Cranmer, who later became the Archbishop of Canterbury and the author of the Book of Common Prayer, was born in Aslockton in 1489. The white-fronted building on the left of the photograph is the Cranmer Arms public house, which is named after him. The road opposite the Cranmer Arms is Dawns Lane.

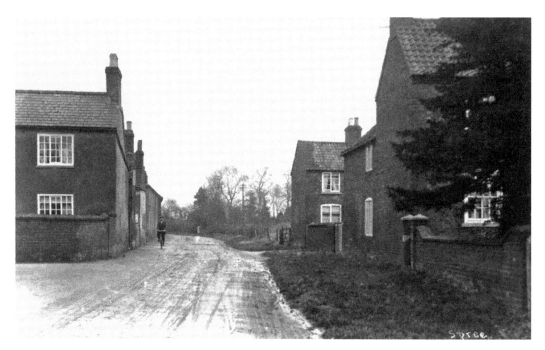

Another image of Main Street. The building to the right foreground is now the vicarage, situated at No. 4 Main Street next to the Parish Church of St Thomas. The building used to be called Normanhurst but was later renamed the Orchard, before becoming the vicarage.

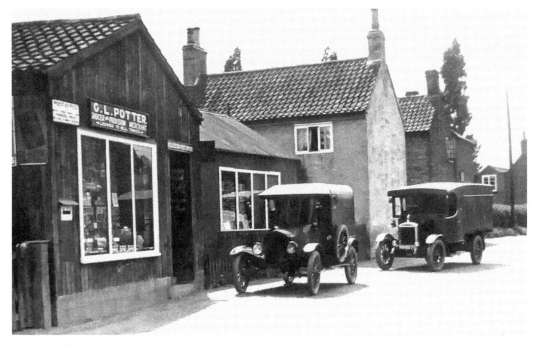

The post office in Main Street. George Potter was the postmaster and also the proprietor of the shop next door. The building is opposite the Greyhound public house. The sign above the shop says 'G. L. Potter Grocer and Provision Merchant Licensed to sell Tobacco'.

Bagthorpe

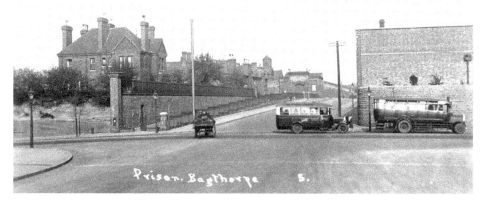

Bagthorpe Prison, located in Perry Road, was built between 1889 and 1891. It originally accommodated 200 male prisoners, but a new block was opened in 1897 to accommodate forty female prisoners. In 1930 the prison closed and was reopened as a borstal institution in 1932.

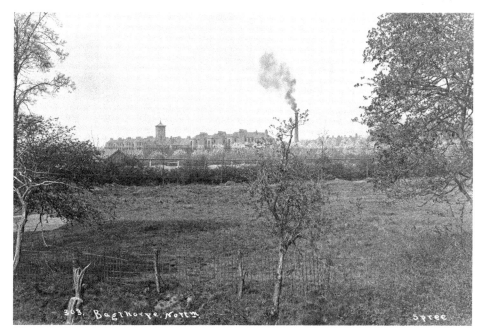

Bagthorpe Workhouse and Infirmary, Hucknall Road, viewed from the south-west. The word 'workhouse' was dropped in 1909. The main accommodation blocks were at the south of the site, with an administrative block at the centre. To its rear were kitchen and dining rooms. The separate infirmary lay at the north of the workhouse. In 1935 it became part of the City Hospital. (Courtesy of Picture the Past, Nottingham City Council)

Basford

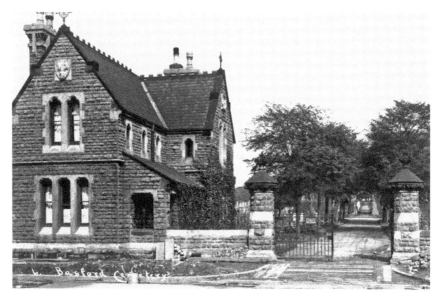

The entrance to Basford Cemetery is located on Nottingham Road, near the junction with Western Boulevard and Valley Road. The cemetery was opened in 1674 and covered 6 acres. It has two mortuary chapels that are of architectural interest.

Bestwood

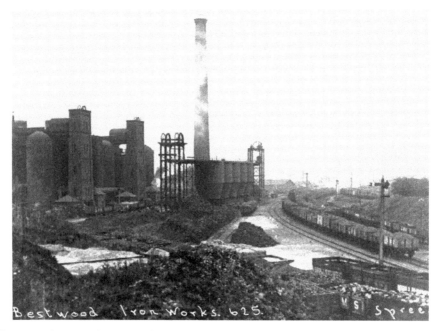

The ironworks opened in November 1881 with two blast furnaces; a further two were added in 1890. The ironworks closed in 1928. The colliery can be seen in the background to the right. The ironworks and colliery were built by the Lancaster family.

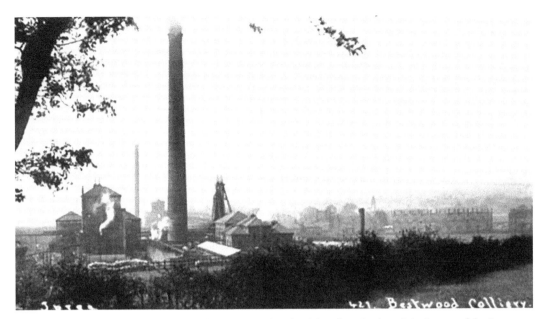

The colliery was sunk in 1875 by the Lancaster family, giving the mine its original name of the Lancaster Drift. The winding engine was commissioned in 1876. To provide for the people coming to work in the mine, the Lancaster's built sixty-four houses, an institute, offices, a school and an ironworks. The pit closed in 1971.

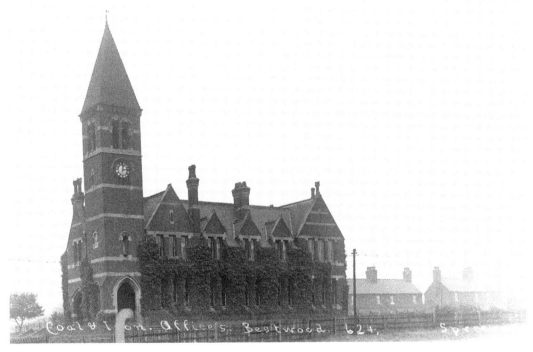

The coal and iron offices are viewed looking north-east from Park Road. Some of the miners' cottages can be seen in the background. This ornate building has been used as commercial premises in more recent years.

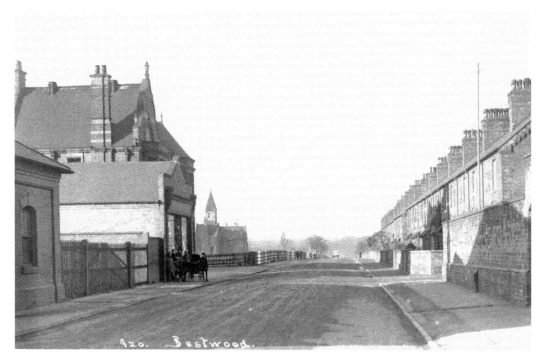

Park Road, looking from the corner of St Albans Road towards Moor Road. The building where the children are standing was demolished and the pithead baths constructed. The building behind this is the Bestwood Hotel. The tower of the Bestwood Coal & Iron offices can be seen in the left background.

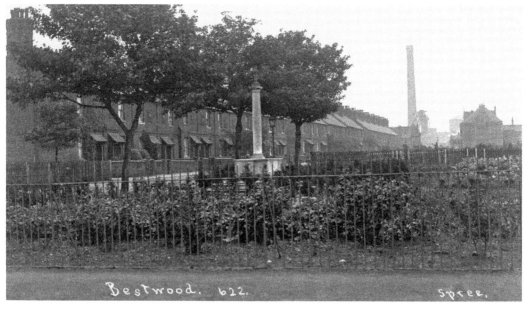

The village memorial, located on Park Road, was unveiled in 1921 by Lord Osborne Beauclerk. The miners' cottages running along Park Road and the ironworks chimney in the background are also a feature. The memorial is in front of the Bestwood Coal & Iron offices, which is out of view to the right of the photograph.

Blidworth

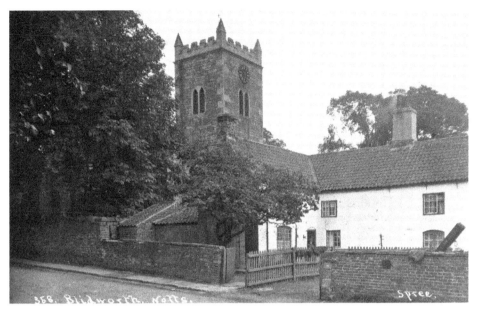

Cottages and the church tower in Main Street are viewed here from the north-west. The Church of St Mary of the Purification dates from the fifteenth century. The unique 'Rocking Ceremony' is held here when a baptised baby boy born nearest to Christmas is 'rocked' in a flower-decked cradle. The names of those babies rocked are recorded in the church.

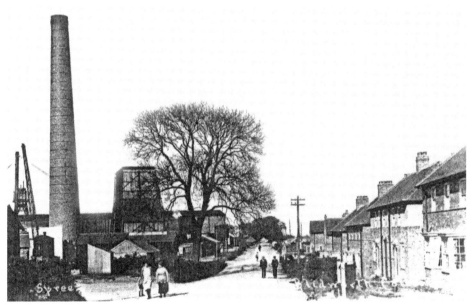

The colliery was originally called Newstead Colliery No. 2 Shaft sinking started in August 1923, with the top hard seam reached in January 1926 at a depth of 721 yards with a coal thickness of 4 feet. The construction of the colliery, north of Belle Vue Road, resulted in the construction of housing for workers, some of which are seen on the right of the photograph. The colliery closed on 1 March 1989.

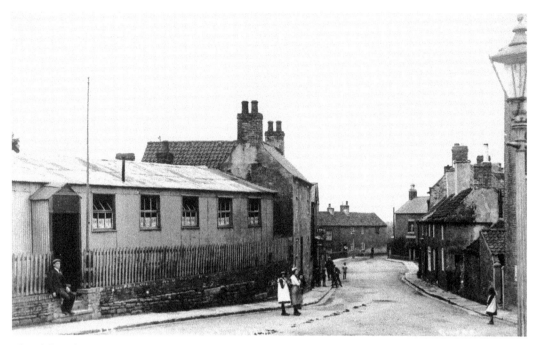

The Blidworth Ex-Servicemen's Institute, where the men of the village – aged over fourteen years old – gathered to play billiards, snooker and cards for recreation. The village street was illuminated by gas lamps hanging from wall brackets. House lighting was also by gas, although many of the poor still used oil lamps.

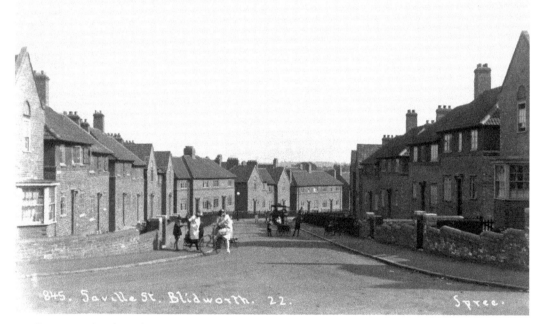

845. Saville St. Blidworth. 22. Syree.

Saville Street, taken from the junction with Haywood Avenue, looking south-east towards Dale Lane. The house on the left-hand corner is No. 57 Saville Street. There is no problem with the children playing in this street, which is completely free of traffic.

Bulwell

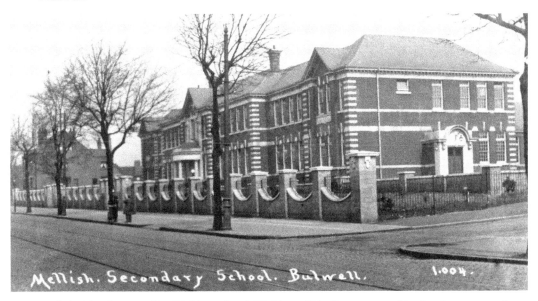

Mellish School, situated in Highbury Road, Highbury Vale. It was opened in October 1929 and was named after an Eton-educated British Army colonel who became a local councillor. It was originally a county grammar school before it became a city secondary school. (Courtesy of Picture the Past, Nottingham City Council)

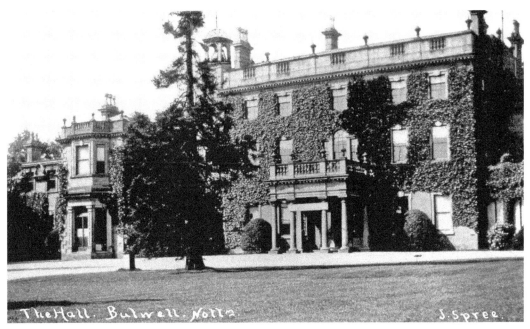

Bulwell Hall, situated to the north-west of Nottingham, was built in 1770. In 1908 Alderman Albert Ball purchased Bulwell Hall and 575 acres with mineral rights. He later sold 225 acres to Nottingham Corporation, on which the Bulwell Hall housing estate was built. The hall and the rest of the estate became a public park. During the 1930s the hall became a sanatorium. It was demolished in 1958.

Burton Joyce

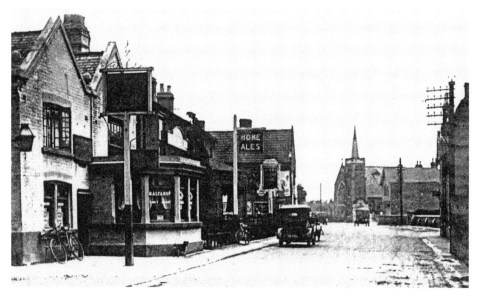

Burton Joyce's Main Street, showing the Home Ales Wheatsheaf Pub next to the Cross Keys pub. The Wheatsheaf was demolished in the mid-1960s to facilitate the building of a car park for the Cross Keys pub. The sign in the window of the pub advertises 'Maltanop', which was a brand of pale ale made by the Nottingham Brewery.

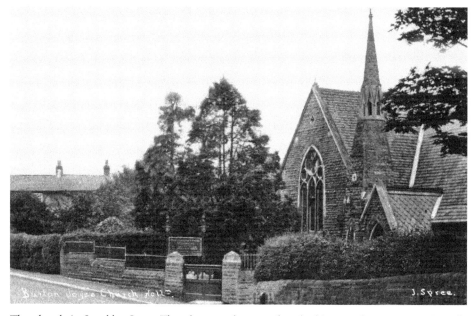

The church in Lambley Lane. The photograph was taken looking north-west approximately 330 yards from the Main Street and Nottingham Road junction, and shows the United Reformed Church, which was formerly known as the village's Congregationalist church. It was founded after a donation by local tradesman Samuel Milne in 1896. (Courtesy of Picture the Past, Nottingham City Council)

Carcolston

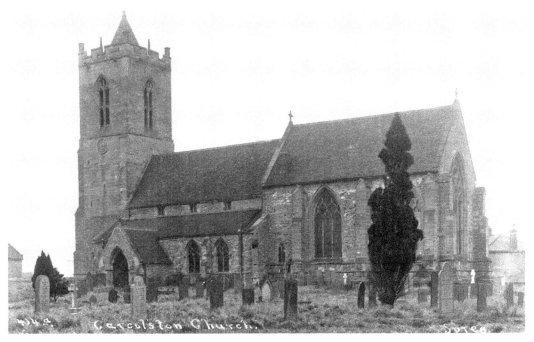

A view of St Mary's Church, taken from across the graveyard on Screveton Road. The junction with Spring Lane is off the photograph to the left. The church dates from the thirteenth century and the tower was restored in 1911. The church is in the diocese of Southwell and Nottingham.

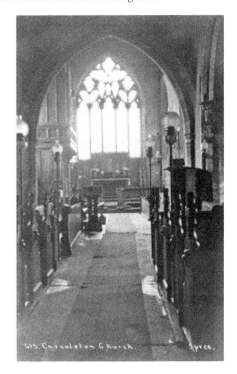

An interior view of St Mary's Church, Carcolston. The church consists of a chancel, north and south aisles, nave, west tower and south porch. The earliest part of the existing structure is the lower part of the tower, which dates from the thirteenth century. The chancel and nave date from the fourteenth century.

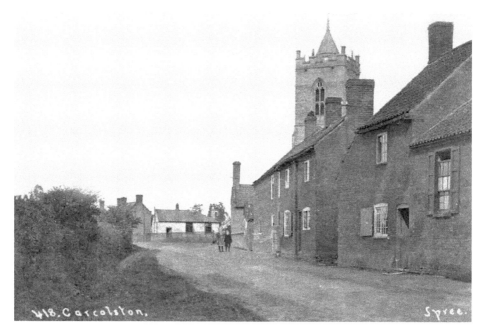

Looking north-east along Spring Lane with the tower of St Mary's Church in the background. Note the two children standing outside of the village post office on what otherwise is a deserted road. The photograph is taken approximately 260 yards north-east of the junction of Spring Lane with Tenman Lane and Car Lane.

Carlton

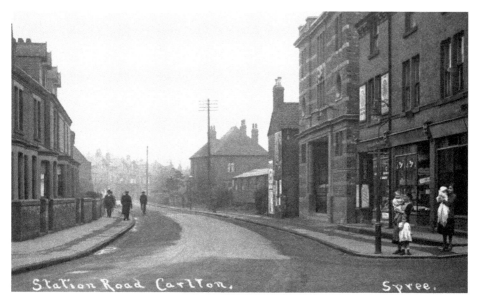

Station Road, looking east from the junction, with Crow Hill Road on the right. The building next to the shop is the Regal Cinema, which opened as the Victoria Palace Picture House on 30 April 1913. The name was changed to the Regal in 1930 and it closed as a cinema in December 1959, after which it became a Pentecostal church.

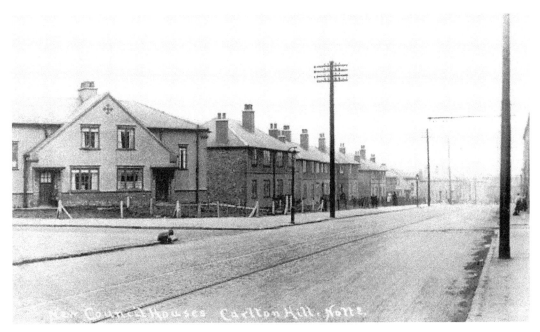

A view of the new council houses looking along Carlton Hill, with the junction of Hooton Road on the left. Note the tramlines in the road. With the impetus from the central government's 1919 Housing Act and with city councillors pressing for more housing, the planning of new council estates began – the Carlton Hill estate was one of these.

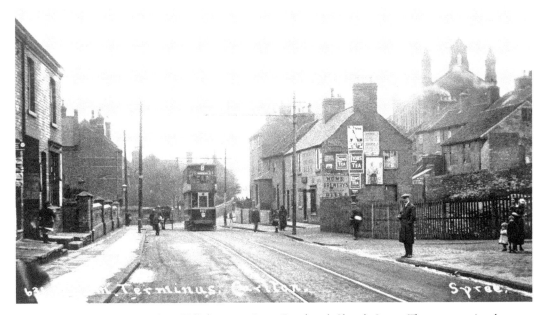

Tram Terminus on Carlton Hill, between Soute Road and Church Street. The tram section between Thorneywood Lane and Standhill Road commenced in September 1913 and was completed by January 1914. It was then extended on the other side of Carlton Hill going into Carlton. This latter section of the Nottingham Tram network opened throughout on 25 June 1914. On the right St Paul's Church can be seen. (Courtesy of Picture the Past, Nottingham City Council)

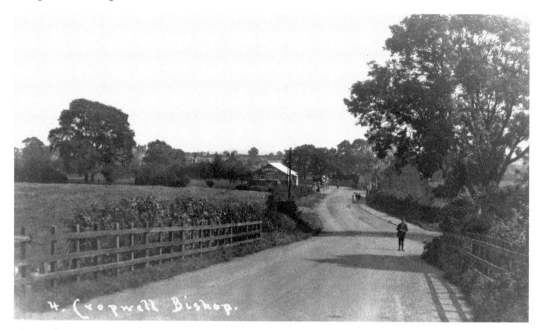

The road entering the village, looking from the south. The tower of St Giles's Church can just be seen to the middle left of the background. The name of Cropwell is derived from a round hill between the villages of Cropwell Bishop and Cropwell Butler.

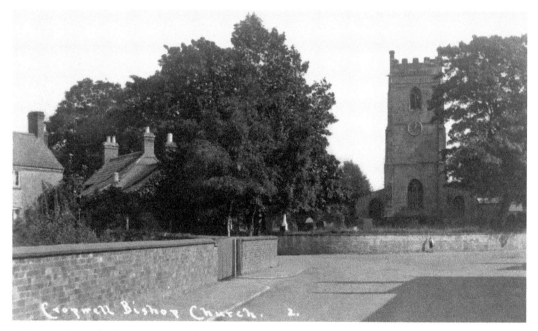

St Giles's Church, looking south-west from Fern Road, near the junction of Church Street on the left. The church has thirteenth-century arcades but it is mainly from the fourteenth century. It has a nave, north and south aisles, a south porch and a chancel. The tower was built around 1450.

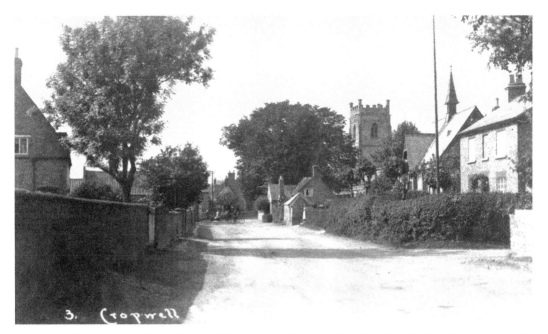

Fern Road and St Giles's Church. The photograph was taken from just before the junction with Stockwell Lane and is looking west. This view shows the tower, which is 60 feet in height and contains a clock that was installed in 1907. At the time of this photograph the tower contained five bells, four of which were cast in 1618. A fifth bell was cast in 1906.

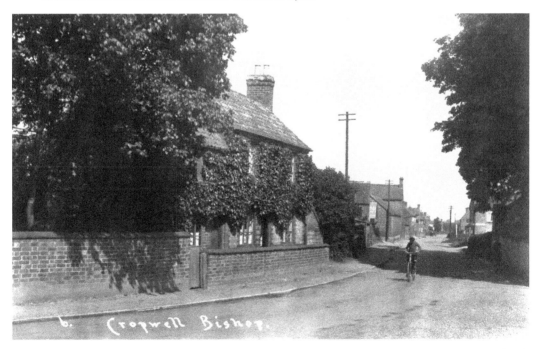

Looking north along Church Street at the junction of Nottingham Road. The wall of St Giles's Church is on the right-hand side. The old village was centred around the vicinity of Fern Road, Nottingham Road and the church on Church Street.

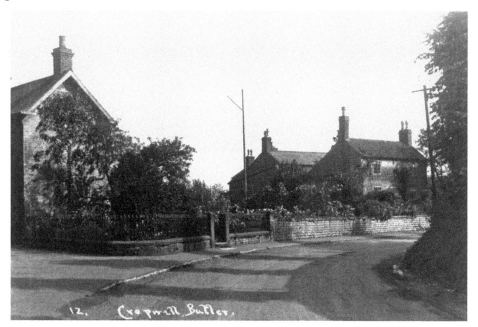

Main Street, looking south-east from just past the junction with Back Lane and Hardigate Road. The village of Cropwell Butler lies 1 mile north of Cropwell Bishop. While Cropwell Butler never had a parish church, there was an Anglican chapel of ease.

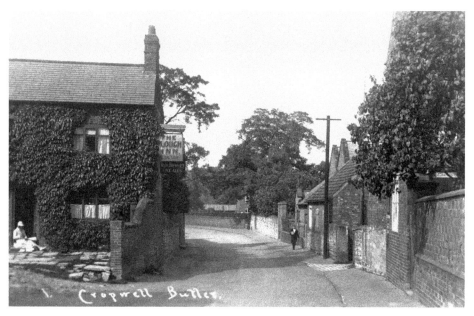

The Plough Inn public house on Main Street, taken from just past the junction with Tythby Road and looking north. The chapel of ease built in 1845 is opposite the Plough Inn. The chapel was closed from 1879 to 1897, but was reopened as St Peter's Mission Church in 1897. It existed throughout most of the twentieth century until closure in 1976.

Dunkirk

View of Dunkirk showing the Beeston Canal. The bridge in the background is on the railway line between Nottingham and Beeston stations. The canal goes under Clifton Boulevard just beyond the rail bridge. (Courtesy of Picture the Past, Nottingham City Council)

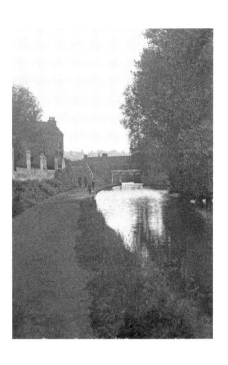

East Bridgford

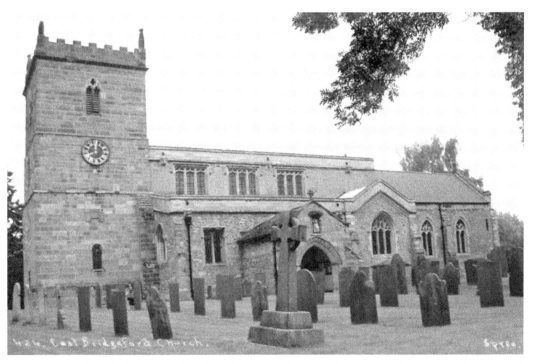

St Peter's Church, located on Kirk Hill, dates from the eleventh century with restoration in 1671 and 1686. The tower was rebuilt in 1778 and the chancel windows were renewed in 1862 when the organ chamber and Lady Chapel were also rebuilt. There were three further periods of restoration work in 1901, 1903 and 1914.

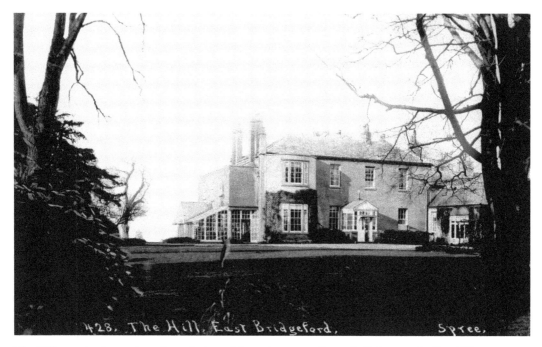

The Hill mansion house dates from the late eighteenth century. It was built in 1792 by Revd Thomas Beaumont for his own use when, as curate in charge, he let the existing rectory of St Peter's Church as a private school for girls.

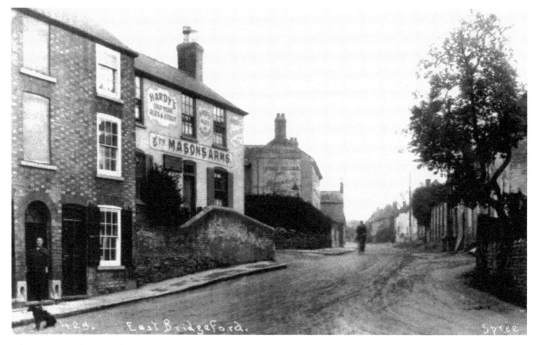

The Masons Arms public house is located in Main Street and according to the photograph is the purveyor of Hardy's fine ales and stout. Thought now demolished, it once stood opposite the Royal Oak public house.

Elston

Elston Mill was built in 1844. After the mill had passed into the ownership of the Gash family in 1919 it began to produce food for farm animals. The Gash family ran a local bus service and at some time in the 1920s it became the base for their vehicles.

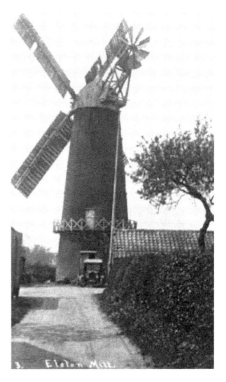

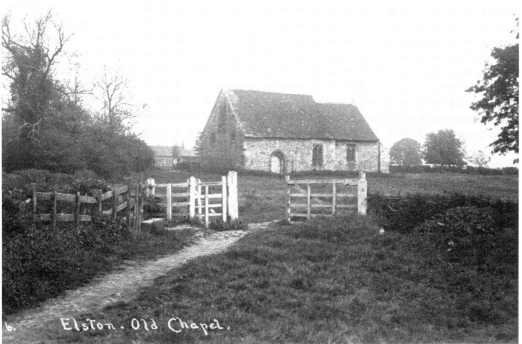

The Old Chapel is located at the end of Old Chapel Lane towards Stoke Field, which was the site of last battle in the Wars of the Roses. Elston Chapel exhibits Norman masonry and fourteenth-century windows. The photograph is taken from the north-east. The chapel was declared redundant in 1976.

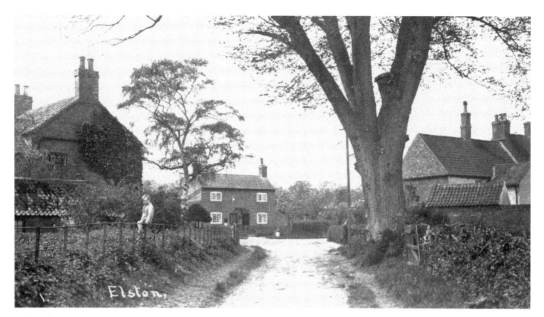

Old Chapel Lane, looking west towards Low Street. The large tree has since been cut down but the three properties still exist, as does the telegraph pole. The iron railings have been replaced by a hedge. The building on the left is The Poplars, which is named after the trees in the vicinity.

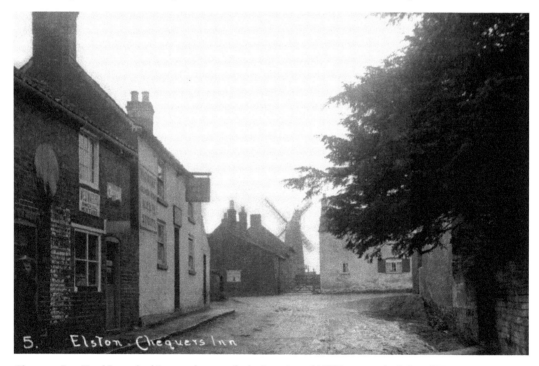

Chequers Inn, Toad Lane, looking north towards the junction of Mill Lane on the left and Top Street on the right. Toad Lane runs roughly north to south, connecting Top Street with Low Street. The inn dates back to the early eighteenth century. The white building was another pub that was closed in 1915 and became a private residence. Elston Mill in Mill Lane is seen in the middle background.

Gedling

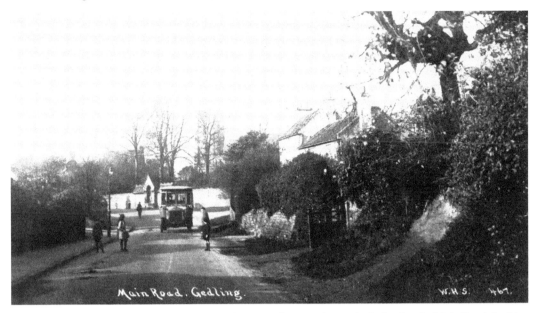

This Spree postcard retailed by WHSmith Nottingham is of a single-decker bus in Main Road, looking towards the junction with Arnold Road. Just outside the rectory gates in the background is a drinking fountain that was presented to the villagers in 1874 by the late Countess of Carnarvon.

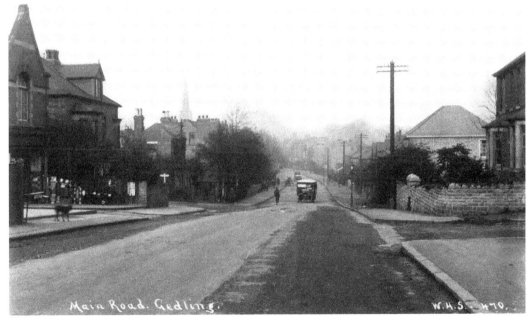

Another Spree postcard published by WHSmith. This one is looking north on Main Road from the junction of Blackhill Drive on the right and with Westdale Lane on the left. In the background the spire of the All Hallows Church can be seen. It is situated on Arnold Lane and, at 180 feet, is the second highest in Nottinghamshire.

Gonalston

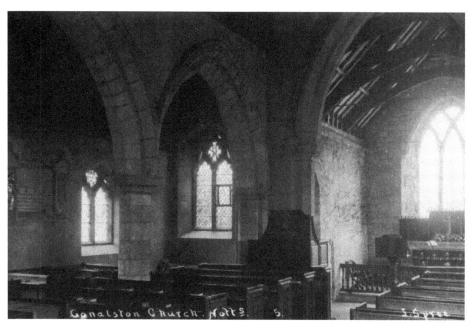

An internal view of St Lawrence's Church looking east from the nave towards the chancel and altar. The church was mainly rebuilt in 1853 but the chancel walls are original and date from around 1300. The church is located on Southwell Road.

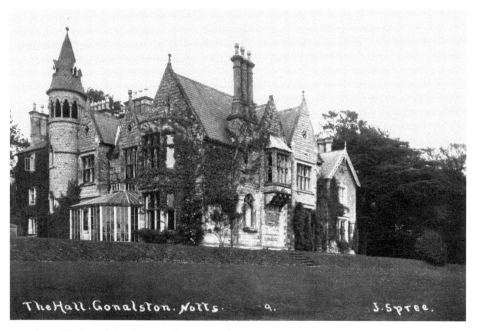

Gonalston Hall was initially an early nineteenth-century hunting lodge. It was later remodelled in 1851–52 as the residence of the then Sheriff of Nottingham. The hall is located on an unnamed road between Gonalston Lane and Southwell Road, near St Lawrence's Church.

Granby

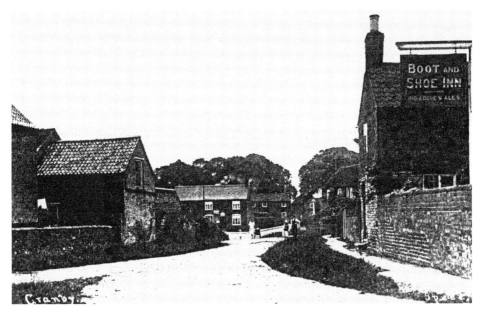

A view of Church Street and the Boot and Shoe Inn – this was sold by the Belvoir estate in 1920. Built in brick with a slate roof, it then contained a back entrance, taproom, parlour with a serving bar, kitchen, scullery, dairy, cellar, four bedrooms and wash house. It can be seen from the sign that they served Ind Coope ales.

Gunthorpe

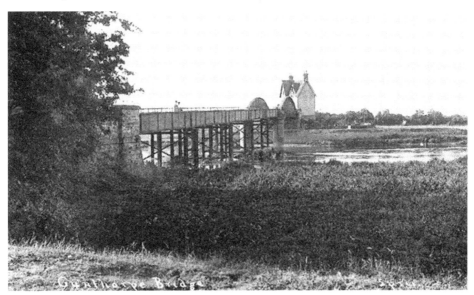

The old bridge over the River Trent. Until 1875 the only way to cross the river was by ferry or ford. The Gunthorpe Bridge Co. was formed in the 1870s to build the bridge. The foundation stone was laid in 1873 and the bridge opened in 1875. It was built largely in iron.

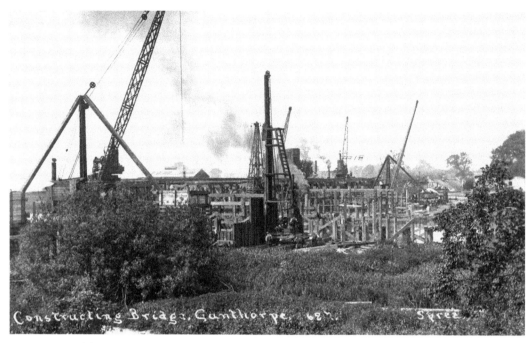

Construction of the new bridge over the River Trent. The Nottinghamshire County Council Gunthorpe Bridge Act of 1925 empowered them to buy out the owners, demolish the old iron bridge and replace it with a three-arched concrete one, construction of which began in 1926.

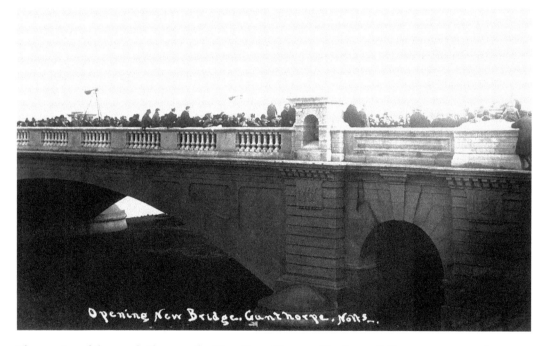

The opening of the new bridge over the River Trent. The new Gunthorpe Bridge was constructed as part of road improvements linking the Fosse Way to the Great North Road. The bridge was opened by the Prince of Wales on 17 November 1927.

Hawksworth

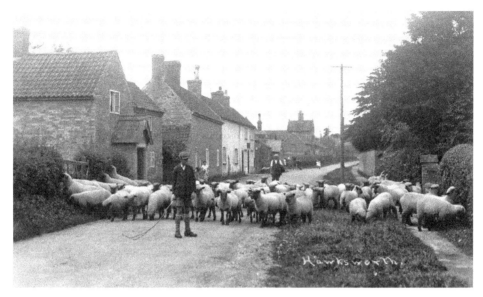

A shepherd herding the sheep. The view looks west from the eastern end of Town Street. The distinctive roof in the background is the farm building at the junction of Main Street. The sheep are doing a good job of keeping the verges tidy.

Hickling

A two-storey thatched cottage in Main Street. The cottage shown, if still existing, would later have had its roof replaced with slate. The building layout is similar to a number of existing properties in the village.

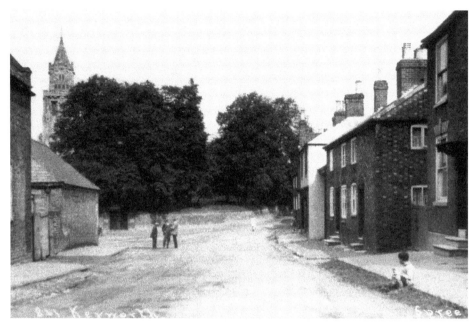

Mary Magdalene Church and grounds at the end of Main Street, with Nottingham Road to the left and Selby Lane to the right. The church dates from the fourteenth century. The church went through a period of restoration between 1871 and 1872.

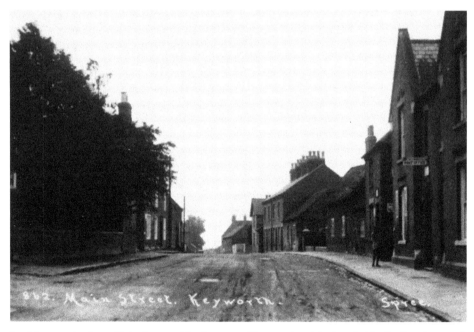

Looking south along Main Street with the post office on the right-hand side. In the nineteenth century the village developed around Main Street, which was previously called Town Street, but there was also some extension along Selby Lane and Elm Avenue.

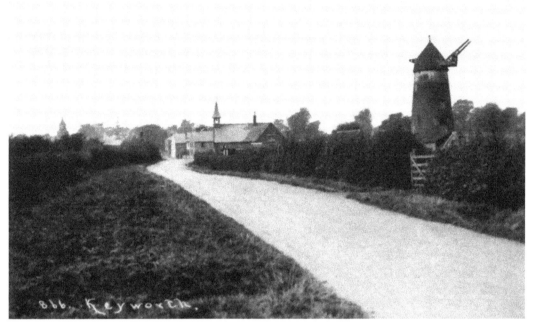

The windmill on Selby Lane. The distinctive tower of the Board Infant School, which opened in 1874 and closed in 1985, is in the centre of the photograph. The church tower of St Mary Magdalene's is to the left. The windmill has lost its sails and was demolished in the 1950s.

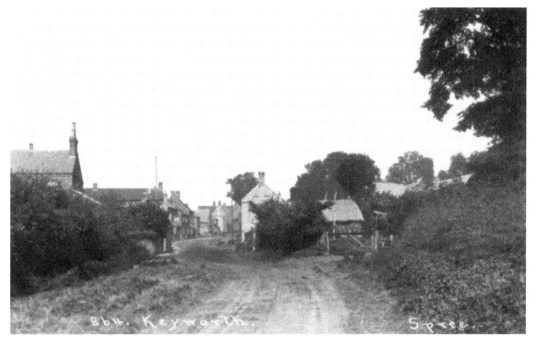

The view from the top of Lings Lane, near the junction with Main Street. The Salutation Inn, which was recorded as a pub as early as 1675 in the Nottingham sessions roll, can just be seen to the centre left of the photograph.

Lambley

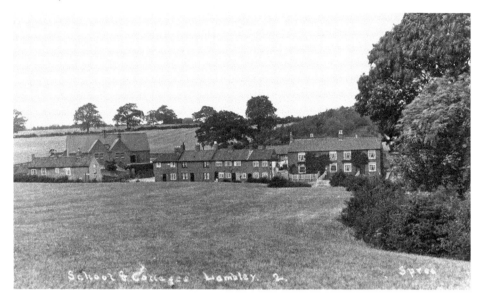

The school and cottages. The school situated in Catfoot Lane opened in 1870 and was taken over by the council in 1907. The feature of the school building is the distinctive double gables. The current building bears little resemblance to the one shown as the gables were demolished around 1970.

Lenton

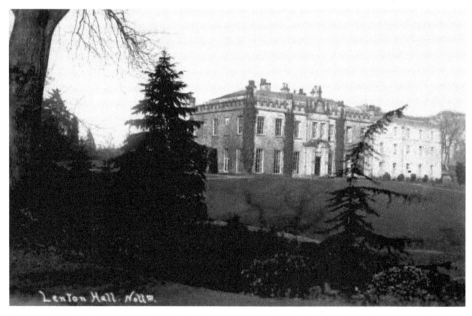

Lenton Hall in the University of Nottingham grounds, off Derby Road. The house was built for John Wright in 1804. In 1930 Lenton Hall was purchased by University College and converted into a hostel for fifty male students. In 1938, after extensive extensions, Lenton Hall was renamed Hugh Stewart Hall.

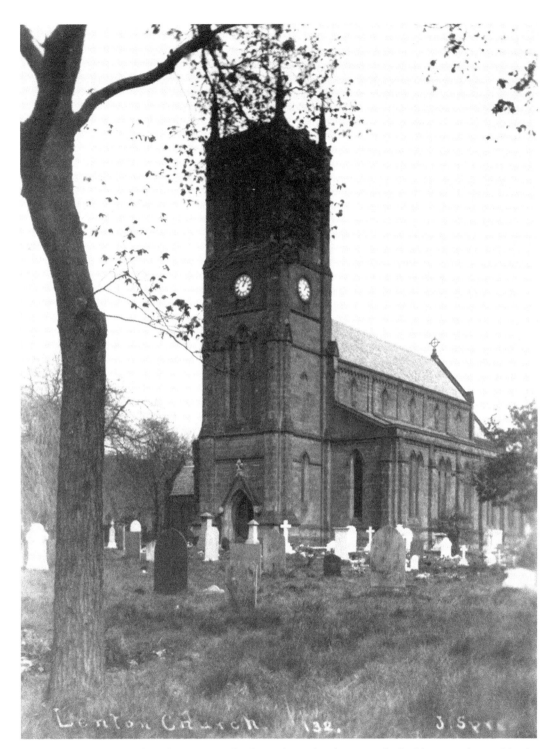

Holy Trinity Church and its graveyard is located on Church Street. The building was designed by the architect Henry Isaac Stevens and opened in 1842. It was consecrated on 6 October 1842 by the Lord Bishop of Lincoln, Rev John Jackson.

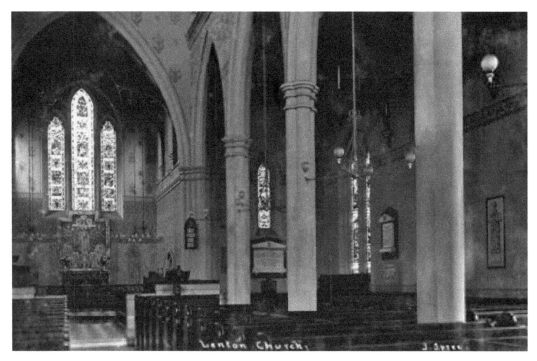

An interior view of Holy Trinity Church looking south-east to the chancel. Holy Trinity is famous for its twelfth-century font, which was originally built for Lenton Priory and was given to the church in 1842. The font is just off the photograph on the right-hand side of the foreground.

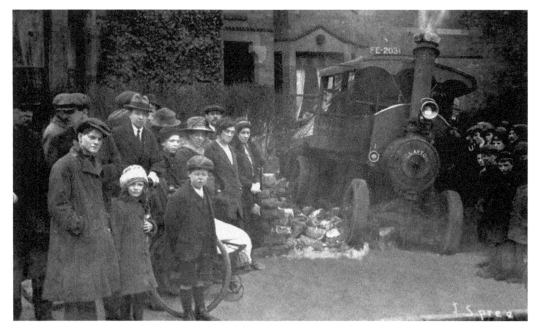

A steam engine with the registration number 'FE-2031' after it had crashed through the garden wall of No. 259 Derby Road, just west of the junction with Lenton Boulevard. The vehicle is an Overtype steam traction engine that was made by Clayton & Shuttleworth of Lincoln.

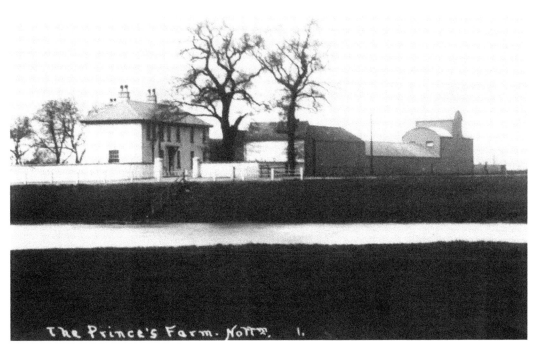

The Prince's Farm was bought by Edward, Prince of Wales in 1927, allegedly to use for the purpose of his affair with Freda Ward, who he had met in London and was the daughter of a Nottingham lace manufacturer. The prince sold the property in 1933 and, after a number of owners, it was bought by the University of Nottingham in 1960.

The Albert Ball memorial at the junction of Sherwin Road and Church Street. The formal unveiling of Lenton's war memorial was on 29 May 1920. The photograph was taken before the Albert Ball memorial homes were completed in 1922. The sign is of the builder W. T. Norris & Sons, who undertook the work on the homes. Holy Trinity Church can be seen in the background.

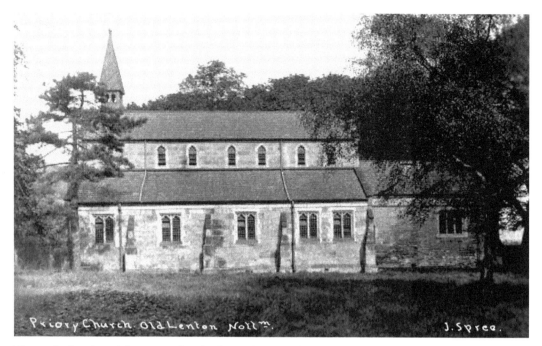

The south elevation of the Priory Church of St Andrew, which is located in Gregory Street. The chancel on the right dates from the days of the priory when it was part of a hospital chapel, but the nave on the left is relatively recent with it only dating from the 1880s.

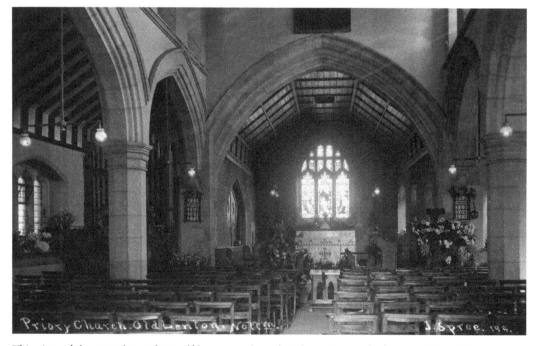

This view of the nave shows the twelfth-century chancel at the eastern end of Lenton Priory Church. The chancel has a nineteenth-century moulded arch without responds and a boarded wagon roof. The eastern end also has a nineteenth-century three-light stained-glass window.

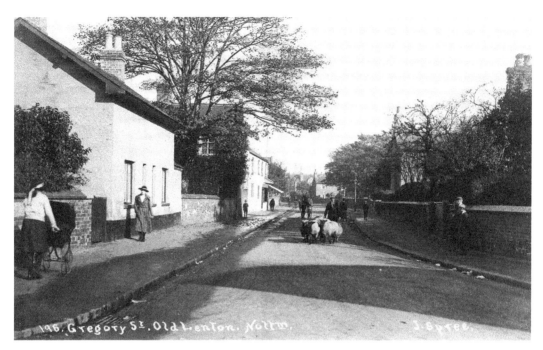

The photograph was taken from the junction of Leen Gate on the left of the foreground and looking north. The building in the middle distance on the left, with the awning over the pavement, is Ball's butcher shop at No. 22 Gregory Street.

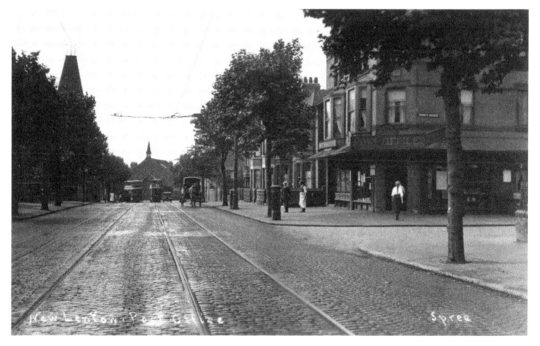

The new post office is shown on the right at the junction of Lenton Boulevard and Trinity Avenue. The man standing outside the shop in overalls is the postmaster Walter Burns, who died in 1925. The tower of the Lenton Council Infants Department is on the left.

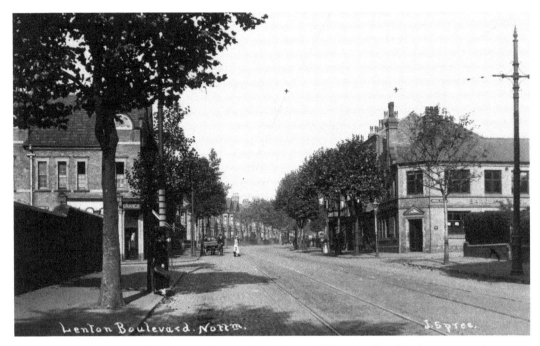

A view of Lenton Boulevard looking north towards Derby Road showing the Church Street junction. Barclays Bank is at the junction on the right of the photograph and the second branch of the Nottingham Cooperative Society is on the left.

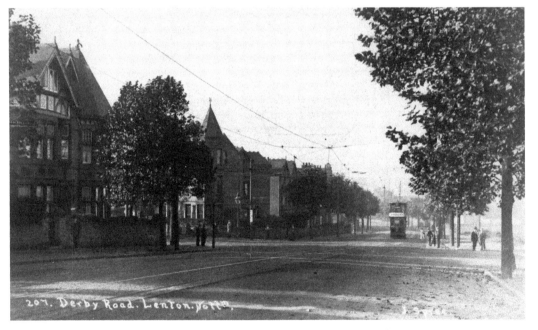

Derby Road looking south-west just before the junction with Lenton Boulevard. The No. 9 tram is on the line heading into Nottingham. The line from Nottingham along Derby Road to Gregory Boulevard was opened in September 1914 and was extended to the Wollaton Park Lodge gates in 1927; this was the last extension of the Nottingham tram system.

Lowdham

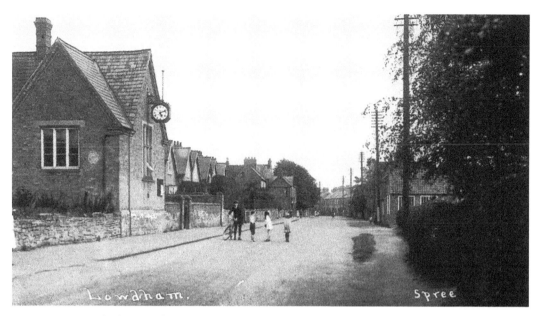

Main Street looking north near to the junction with Tun Lane, which is just visible on the right. The Church of England infant school with the school clock, which shows the time as being 5.10 p.m., is a prominent feature.

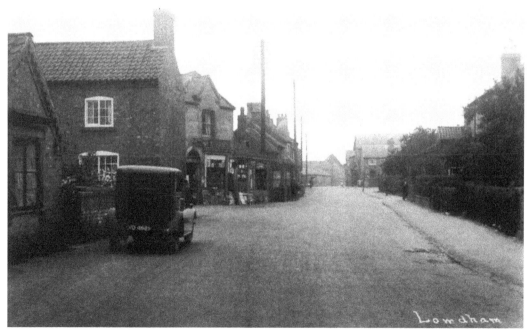

Main Street, looking north-west just past Morley's Close. The parked car has the number plate 'VO 4685', which is an old Nottingham registration mark. Parr's shop, offering a telephone service to the public, is on the left-hand side of the photograph.

Victoria Mills, situated at the northern end of Epperstone Road. This water mill and house with a footbridge was built in the middle of the eighteenth century, with additions being made in the early nineteenth century. The water course through the property is the 'Dover Beck'.

Mapperley

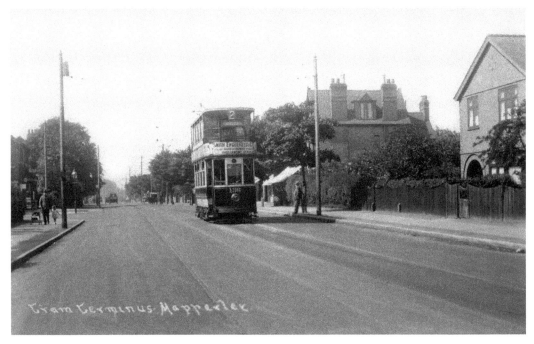

Looking south-west along Woodborough Road, showing the second tram terminus. The terminus is just beyond the corner with Westdale Lane on the left. The No. 2 tram carries an advert for Smith Englefield, who sold bags and trunks at premises in Parliament Street in Nottingham.

Nottingham

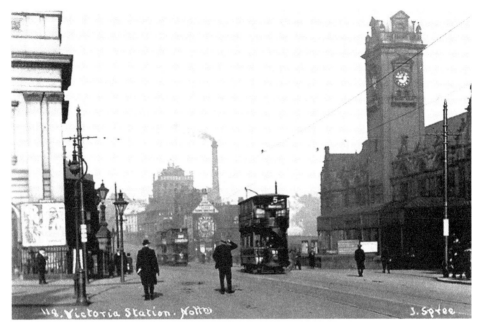

Victoria station on Milton Street was a Great Central and Great Northern Railway station. It opened in May 1900 and closed in September 1967. A No. 5 tram is en route between Nottingham Road, Radford and Lenton. On the left at the junction with Burton Street is the Mechanics' Institute, which housed a cinema in its main hall.

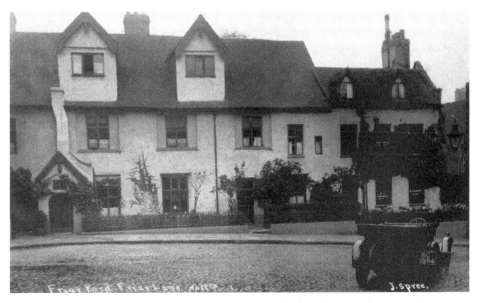

Friar Yard on Friar Lane, near Beastmarket Hill. Named after the Carmelites, or White Friars, who had a friary there until the middle of the sixteenth century. It was then bought and modernised by John Manners, the younger son of the Earl of Rutland, who married Dorothy Vernon, the daughter of Sir George Vernon.

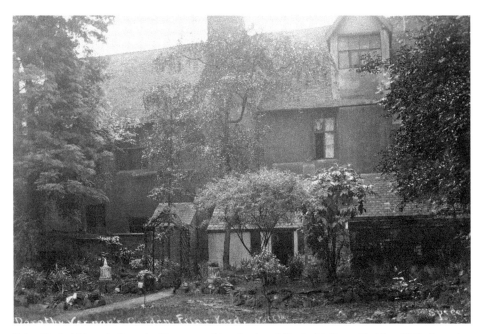

Friar Yard. Although Dorothy Vernon and her husband lived chiefly at Haddon Hall, they also spent part of their time in a wing of the old friary – hence the gardens at the back of the building becoming known by her name. This photograph is taken of the rear of the building from the end of the garden. (Courtesy of Picture the Past, Nottingham City Council)

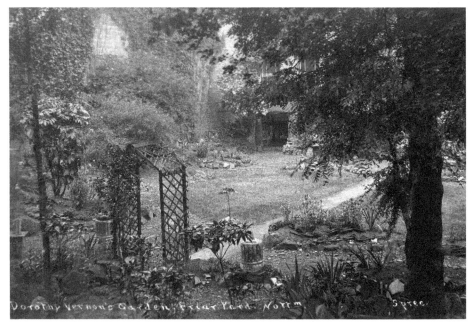

Dorothy Vernon's garden in Friar Yard looking away from the rear of the building to the end of the garden. Dorothy Vernon died on 24 June 1584. The building was partly rebuilt in the seventeenth century and was demolished in 1927 when Friar Lane was widened. (Courtesy of Picture the Past, Nottingham City Council)

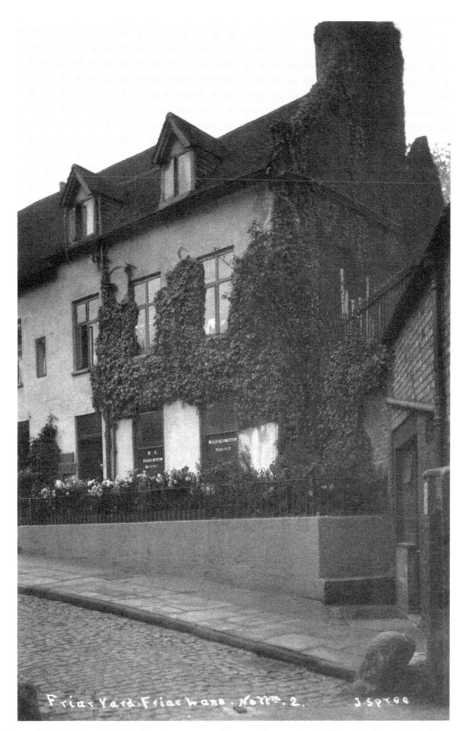

Part of the building in Friar Yard was an architectural practice. William Herbert Higginbottom was born in 1868. After qualifying as an architect he established two practices, including this one at No. 2 Friar Lane. He was responsible for the design of many monumental buildings in and around Nottingham. He died in 1929.

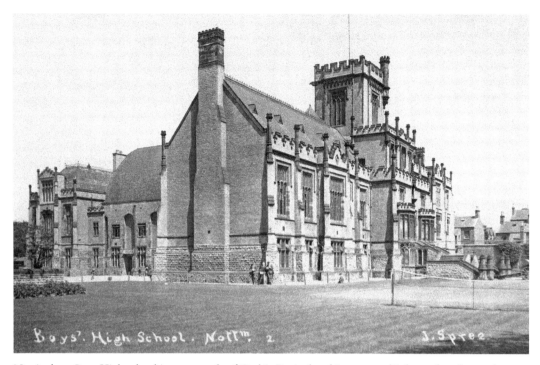

Nottingham Boys High school is an example of Gothic Revival architecture and is located to the north of the city centre on Arboretum Street. This view is taken looking north-east from within the grounds. The main entrance with a war memorial is off to the right of the photograph. (Courtesy of Picture the Past, Nottingham City Council)

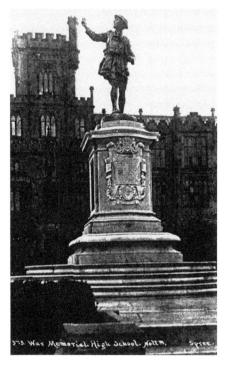

The First World War memorial at the Boys High School. This is a life-sized bronze figure of a young second lieutenant in service dress uniform leading his platoon in attack. The statue surmounts a pedestal of Portland stone set on three steps.

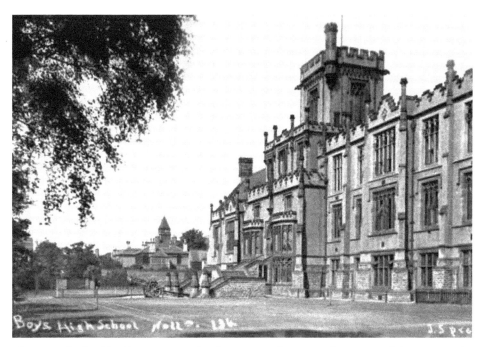

The original school building was completed in 1867 and consists of a tower and three wings: the West Wing, Middle Corridor and East Wing. D. H. Lawrence was a pupil at the school from 1898 to 1901. The tower of the Waverley building can be seen in the background.

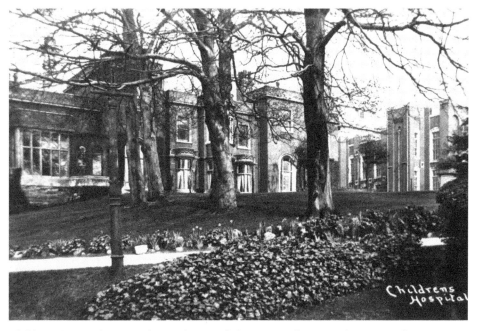

Children's Hospital, Mapperley Park. Founded in 1869, the original accommodation was in Postern Street, Nottingham, but this became inadequate. In 1900 the hospital moved to this accommodation at Forest House, Chestnut Grove, which was given by the lace manufacturer Thomas Birkin. (Courtesy of Picture the Past, Nottingham City Council)

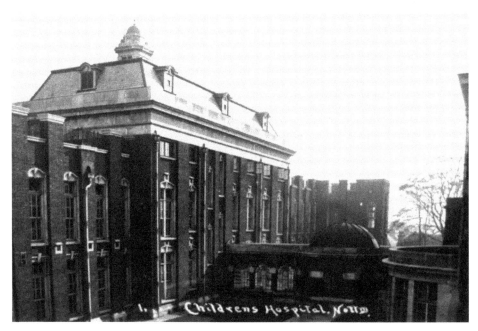

The Forest House building of the Children's Hospital was extended in 1927. This was funded by a donation from John Dane Player of the tobacco firm. In 1978 the Children's Hospital closed and its occupants became the first inpatients of the Queen's Medical Centre. The Forest House building then became the headquarters of Nottingham Health Authority. (Courtesy of Picture the Past, Nottingham City Council)

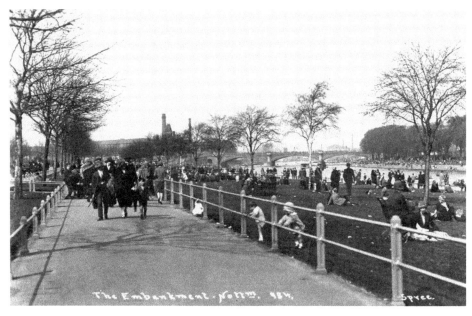

Victoria Embankment by the River Trent. Prior to the new embankment, the river's edge was like any other found along stretches of the Trent, with a simple path that allowed horses to pull barges along the river. Victoria Embankment was constructed between 1898 and 1901 with 10 miles of concrete steps, 7.5 miles of iron fencing and 150 seats.

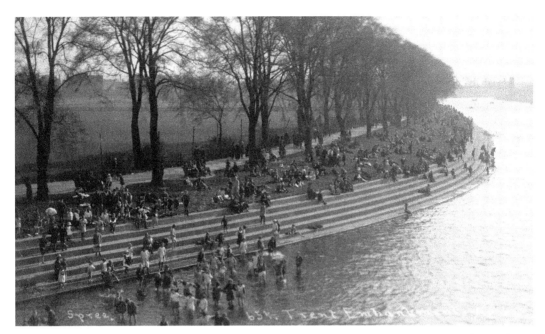

The embankment and the Meadows. As a result of the Victoria Embankment securing the north and west banks of the Trent, work was undertaken on filling and levelling the hinterland. The Meadows Recreation Ground was formed and opened in May 1906 and is seen here behind the tree line. It was photographed from the railway bridge that used to cross the Trent. (Courtesy of Picture the Past, Nottingham City Council)

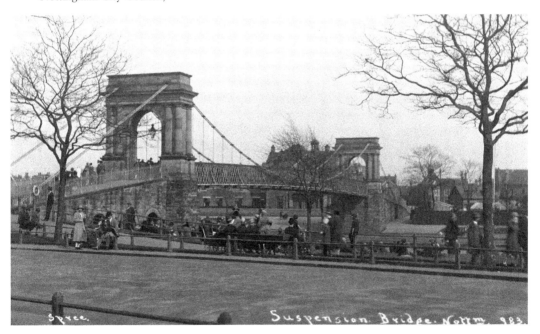

Wilford Suspension Bridge is a combined pedestrian footbridge and aqueduct that crosses the River Trent, linking the town of West Bridgford to the Meadows. Construction started just after the embankment was formed and was completed in 1908. (Courtesy of Picture the Past, Nottingham City Council)

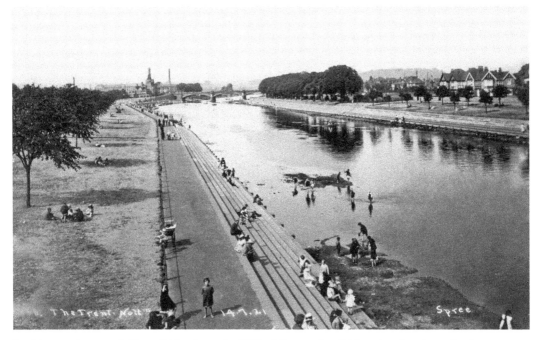

Looking north towards Trent Bridge from the Wilford Suspension Bridge, showing the embankment between the two bridges. The photograph, which was taken on 14 July 1921, shows children taking advantage of the low water level to bathe in the river.

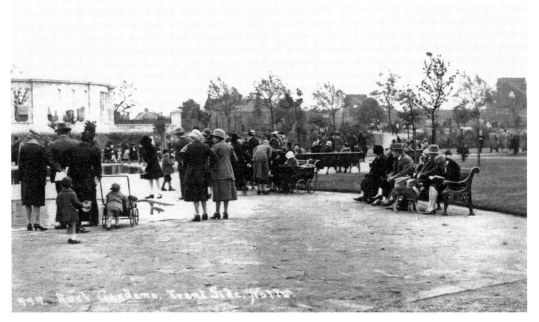

The rock gardens. In 1920 the Clifton estate offered a piece of land to the south of Trent Bridge for sale, located on the west bank and adjacent to the Meadows Recreation Ground. It was bought by Sir Jesse Boot and the land was given to the Nottingham Corporation in 1920 to be preserved as an open space and a memorial site in perpetuity. The memorial gardens included a rock garden.

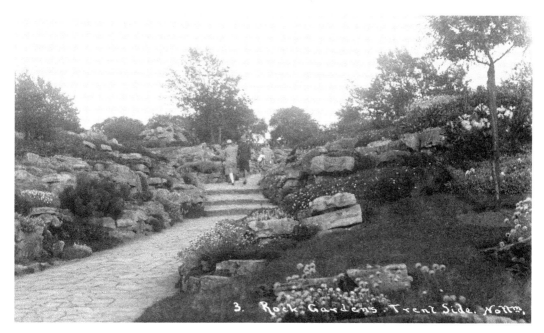

The rock gardens opened in 1926 and are designed to be approached from Victoria Embankment in the east. The main entrance is marked by the Memorial Arch, which overlooks the river and dominates the area. Paths throughout the rock gardens are laid in stone flags and converge on a circular rose garden. (Courtesy of Picture the Past, Nottingham City Council)

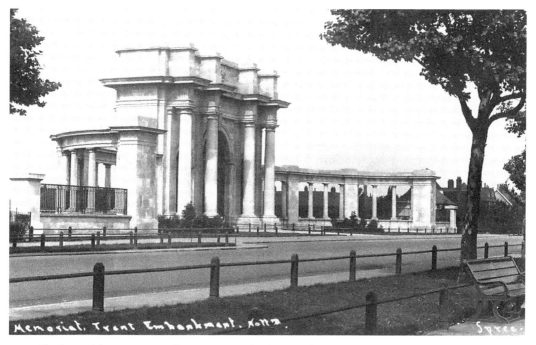

The front of the war memorial on Victoria Embankment. The memorial was designed by T. Wallis Gordon, Nottingham's city engineer and surveyor. It was unveiled by Edmund Huntsman, Mayor of Nottingham, on 11 November 1927 – Armistice Day. The arch forms the entrance to the Memorial Gardens.

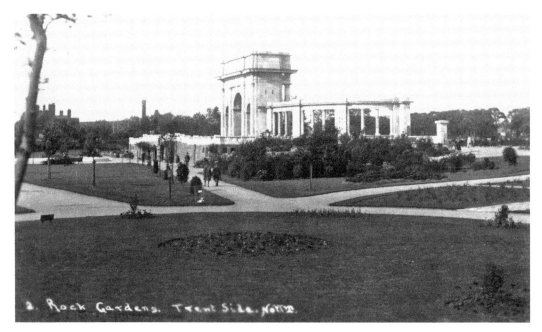

Memorial Arch as seen from inside Memorial Gardens. The Portland stone memorial consists of a three-span archway flanked by colonnades and with a terrace overlooking the gardens and the River Trent. The three-arched openings are enclosed with ornamental wrought-iron gates, and the city's coat of arms is above the main cornice.

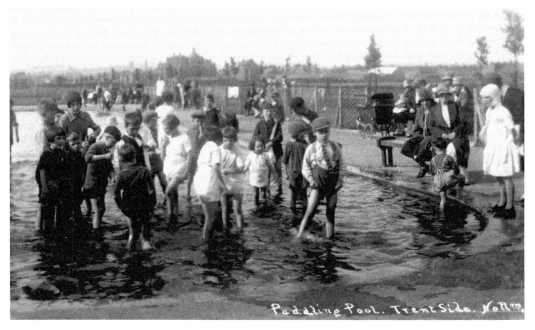

The paddling pool situated in the Meadows at the corner of Wilford Grove and Victoria Embankment. The pool provided a much safer environment than paddling in the adjacent River Trent. The photograph is taken looking north from the embankment, where the river meanders. (Courtesy of Picture the Past, Nottingham City Council)

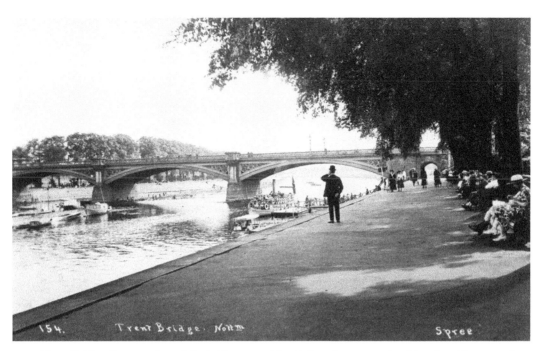

Trent Bridge. Construction of the bridge started in 1868 and was completed in 1871. There are three main cast-iron arches, with each spanning 100 feet. Each arch is braced by wrought-iron girders and the width between the parapets was then 40 feet.

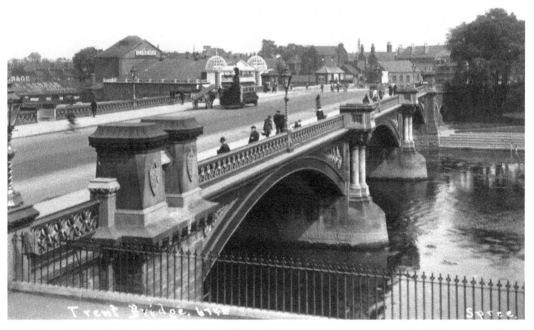

Trent Bridge, looking towards West Bridgford. Between 1924 and 1926 the bridge was widened to 80 feet by the Cleveland Bridge & Engineering Co. to cope with the increase in traffic. In the background to the left is the Pavilion Cinema, which closed in 1927. The Pavilion Cinema was named after the Industrial Exhibition pavilion, which stood on this site in 1903–04.

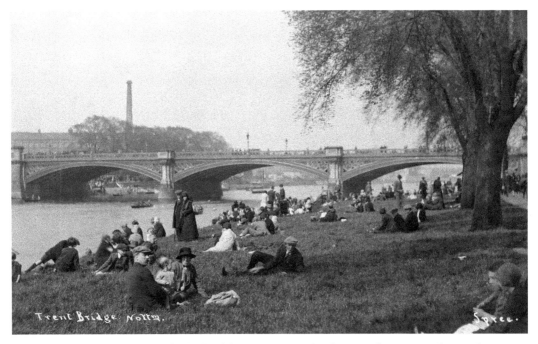

Trent Bridge from the West Bridgford side of the River Trent. The chimney of Turney Leather Works is seen in the left background. The firm was set up in 1861 by two brothers, Edward and John Turney, who built a tannery and began to make leather goods. The factory closed in 1981.

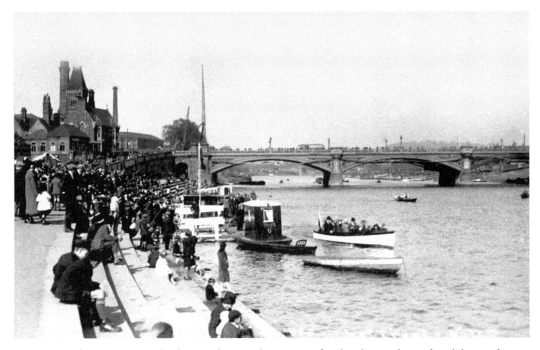

Trent Bridge from Victoria Embankment, showing the pontoon for the pleasure boats that did a good trade. In the background to the left the Town Arms public house and Turney Leather Works can be seen. (Nottingham City Council – Picture the Past)

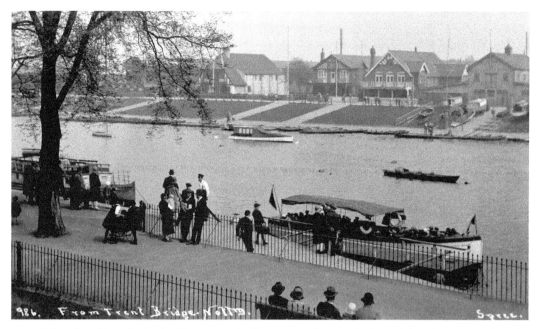

Taken from Trent Bridge looking across the River Trent showing the boat club and rowing club on the 'South Bank'. Behind the tree in the top left of the photograph is the 'City Ground' home to Nottingham Forest Football Club. In the foreground is the 'North Bank' with a landing stage for pleasure boats. (Courtesy of Picture the Past, Nottingham City Council)

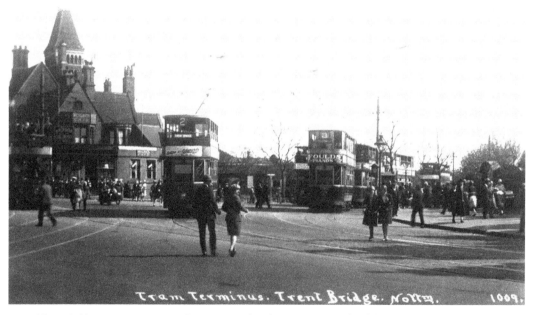

Trent Bridge tram terminus. The Trent Bridge depot was completed by 14 September 1902. Service numbers were introduced for the first time in 1912. The Trent Bridge services were: No. 1 (Sherwood to Trent Bridge), No. 2 (Mapperley to Trent Bridge) and No. 3 (Bulwell to Trent Bridge). In 1907 the terminal line at Trent Bridge was moved from the centre of the road to outside Hickling's Café, seen on the left-hand side of the photograph.

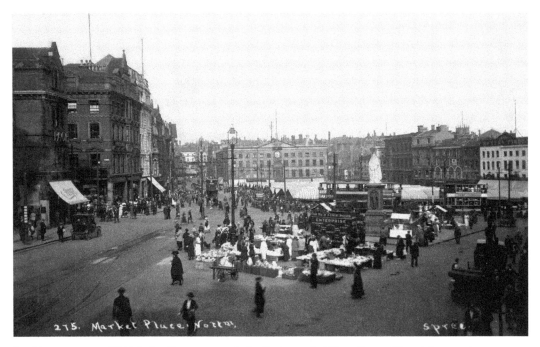

Looking east across Old Market Square towards the Exchange building. Queen Victoria's statue is seen middle right with an Enterprise stall next to it selling beverages with the slogan 'Our Tea is a Great Reviver'. The time on the Exchange building clock is 5.50.

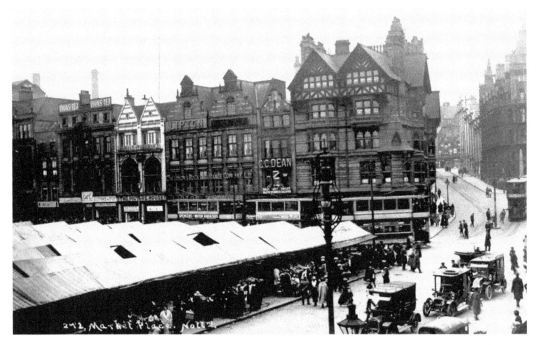

Old Market Square looking north-west from the Exchange building, with King Street on the right. The buildings on Long Row include the Lyons Tea House, Union and Rock Assurance, CC Dean, the Picture House and Queens Chambers on the corner with King Street.

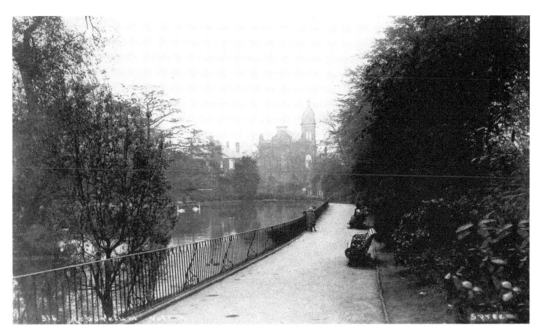

The Arboretum was designed in 1850 by Samuel Curtis and was officially opened in 1852 with 15,000 people watching. It was the first public park in Nottingham. The lake is on a north–south axis and runs parallel to the Waverley Street boundary of the park. The lake was originally around 80 × 30 yards in size but was later made smaller.

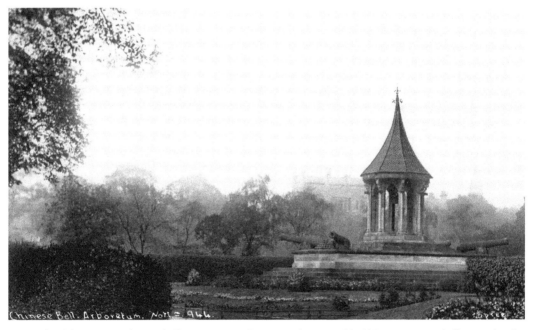

The Arboretum's Chinese bell war memorial. During the war with China in 1857 a bell was taken by British troops from a temple near the east gate of Canton and transported to Nottingham. Two cannons were captured at Sebastopol in 1854–55 during the Crimean War. Two replicas were also made to form with the bell the memorial, which was built in 1862.

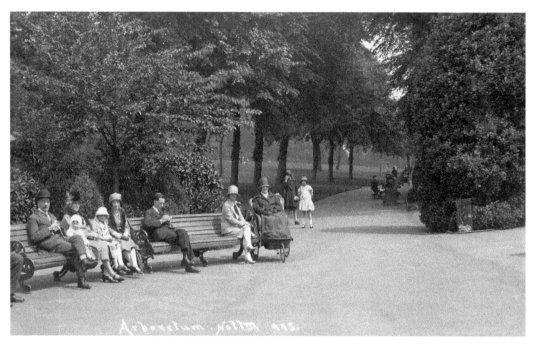

There are many walks around the Arboretum with plenty of benches for visitors to sit and enjoy the surroundings. A spinal walk runs on a roughly east–west axis from the main entrance through the open central lawn to the east entrance. Paths backing onto the perimeter planting encircle the site, with further walks joining the central one. (Courtesy of Picture the Past, Nottingham City Council)

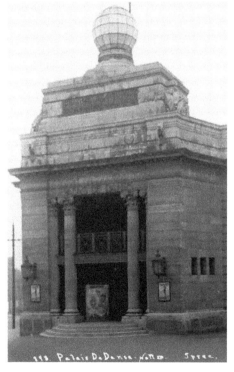

Palais de Danse was built by Midland Palais de Danse Ltd and is situated on the junction of King Edward Street, John Street and Upper Parliament Street. Initially designed as a dance hall and billiard saloon, it opened on Friday 24 April 1925.

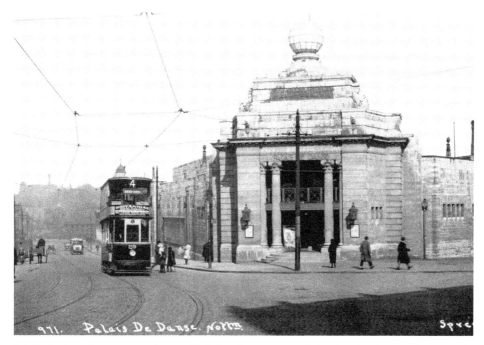

Palais de Danse's entrance, above which is a large ornate globe that is of particular note. As you entered through the vestibule into the foyer the pay desk was on the right-hand side and cloakrooms were on either side.

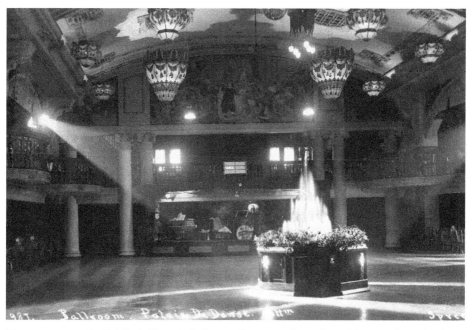

The entrance to the Palais de Danse's ballroom floor was down five wide steps from the foyer. The stage was at the opposite end of the ballroom and a saloon bar was on the right. In the centre of the ballroom was a fountain that sent water up to 20 feet in the air and was illuminated by rainbow-effect lighting. (Courtesy of Picture the Past, Nottingham City Council)

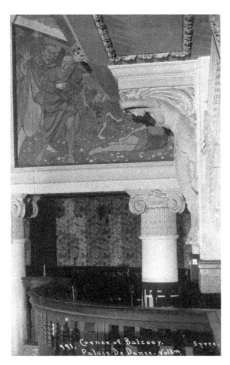

Corner of the balcony at the Palais de Danse. Just after entering the ballroom there were two flights of stairs leading to the first floor and balcony. The balcony overlooked the dance floor with an office off to one side and toilets at two of its corners. (Courtesy of Picture the Past, Nottingham City Council)

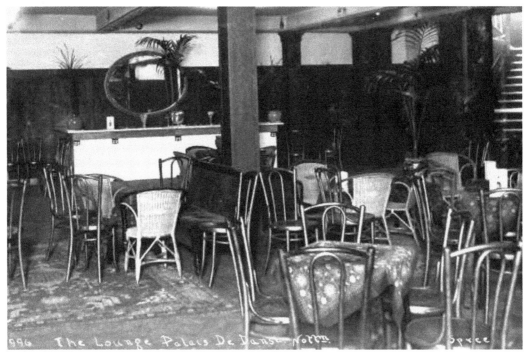

The lounge at the Palais de Danse. Separated from the balcony at the Upper Parliament Street end was also a lounge, reception and more cloakrooms. This area was at a lower level than the balcony and could be also be accessed from the ground floor. The stairs on the right lead up to the toilets in the corner of the balcony.

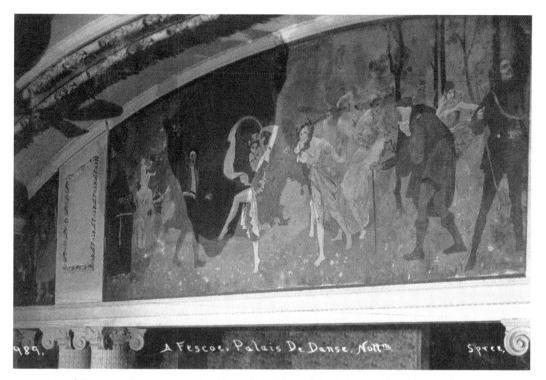

One of the many frescos decorating the walls of the Palais de Danse. The ballroom floor was sprung and could easily accommodate 800 people. For those not dancing there were promenades encircling the entire floor, which were furnished with settees and tables. Notice the misspelling of 'fresco' on the postcard. (Courtesy of Picture the Past, Nottingham City Council)

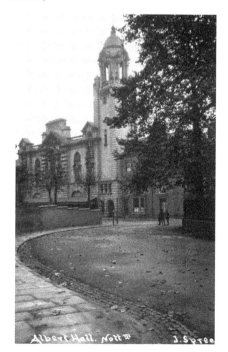

Albert Hall, North Circus Road. This photograph is looking west from Wellington Circus. The building has a breadth of 88 feet, a length of 155 feet and a tower rising to a height of 100 feet.

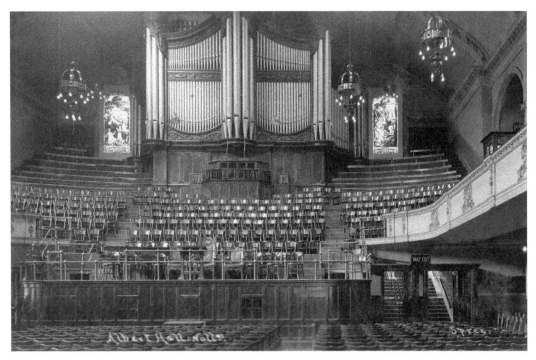

A view looking towards the platform of Albert Hall and the 'Binns Organ', which is named after its manufacturers. The original hall burnt down on the night of 22 April 1906. The Albert Hall seen here was rebuilt on the same site and opened in 1909. The organ was a gift from the chemist Jesse Boot. (Courtesy of Picture the Past, Nottingham City Council)

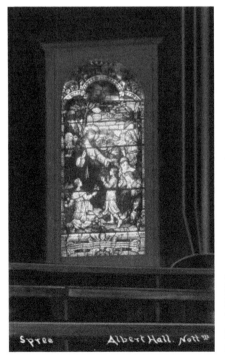

A stained-glass window in the Albert Hall, which is located on the left-hand side of the Binns Organ. It is entitled 'Suffer Little Children to Come Unto Me'. The stained-glass windows are in memory of Eleanor Pearson (died 9 October 1898) and Frederick Pearson (died 2 February 1909).

This stained-glass window is on the right-hand side of the Binns Organ in the Albert Hall. It is entitled 'He Is Not Here He Has Risen'. The windows had originally been placed in the Halifax Place Chapel, but when it ceased to be a Wesleyan Methodist chapel the windows were transferred to the Albert Hall in 1930.

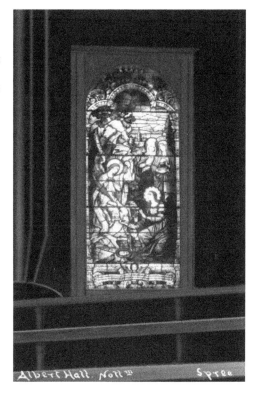

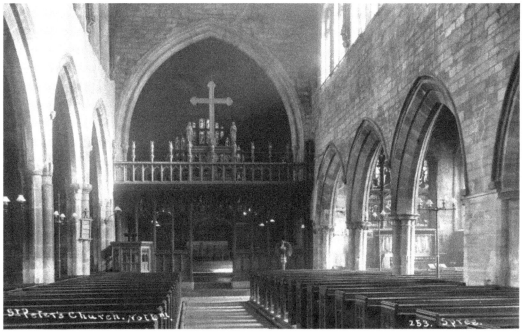

This photograph of the interior St Peter's Church, St Peter's Gate, is taken looking east along the nave to the chancel. Major rebuilding of the chancel and north transept was completed in 1877 and forms most of the church shown here.

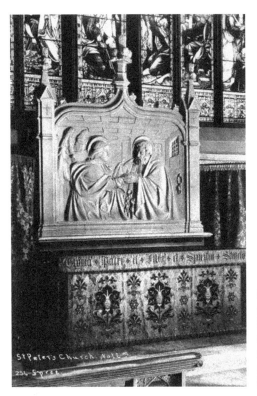

St Peter's Church reredos. Further restoration to the church was undertaken in the 1920s, including the restoration and replacement of old stonework and the creation of a new tracery for the clerestory windows. By this time a sculptured reredos of St Peter's escape from prison had been installed below the east window.

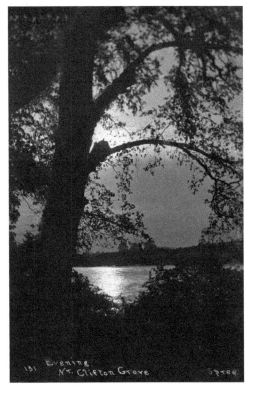

Clifton Grove. The track begins on the south bank of the River Trent, close to Clifton Bridge. Traveling west, it crosses the Fairham Brooke and follows the line of the River Trent to Clifton Woods. The trees in Clifton Grove were planted in around 1740. The length of the Grove is approximately 2 miles. (Courtesy of Picture the Past, Nottingham City Council)

St Andrew's Church is viewed here from Forest Road. It is situated on Mansfield Road, opposite the Church (Rock) Cemetery and on or near the site of the old Nottingham gallows. The church was built between 1869 and 1871 and extended in 1884. It was intended as a daughter church to St Ann's Church.

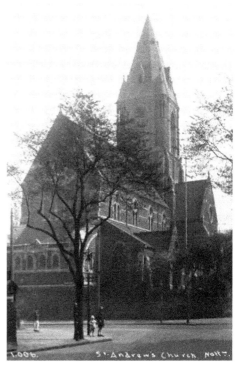

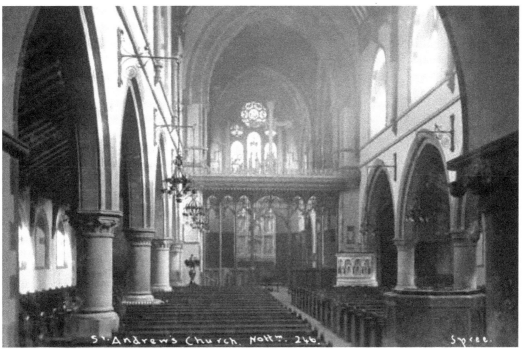

Looking east inside St Andrew's Church, showing the chancel screen. The church was built of rock-faced Bulwell stone and comprises of a nave of four bays and aisles, a chancel under the tower, a sanctuary, transept chapels, a baptistery, north and south porches and a tower containing one bell.

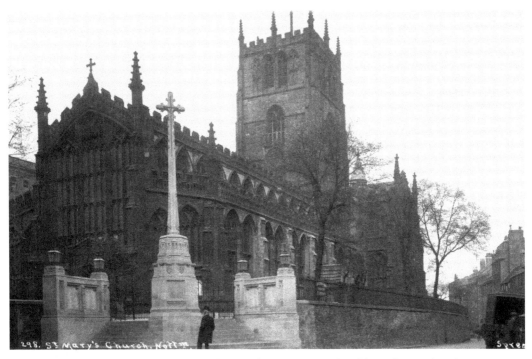

The Church of St Mary the Virgin, located on High Pavement, is the oldest religious foundation in Nottingham. It is the largest church after the Roman Catholic cathedral in Nottingham and the largest medieval building in the city. The county war memorial is in the foreground.

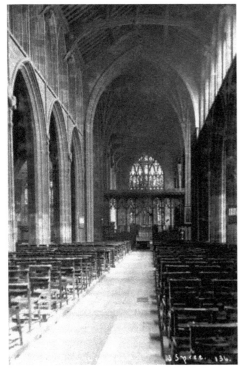

The interior of St Mary's Church, looking east along the nave to the chancel. Roughly a third of the main body of the church dates from the fourteenth and fifteenth centuries. The entire nave was finished before 1475. A major restoration project began in 1843, causing closure of the church. It reopened on 19 May 1848.

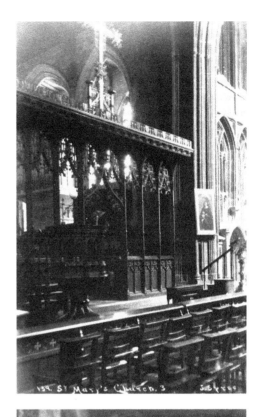

The interior of St Mary's Church, showing the open work oak pulpit. A brass plaque has the following inscription: 'This pulpit was the gift of the Church Congress 1871.' Smaller restoration works and additions to the church took place in the nineteenth and twentieth centuries, including the building of the Lady Chapel in 1921 and the erection of the war memorial in 1922.

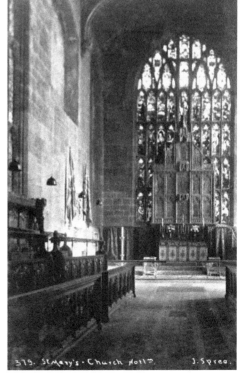

Another image of the interior of St Mary's Church – this time looking east and closer to the chancel. The internal dimensions of the church are 215 feet from west to east, 100 feet from north to south, and the tower stands 126 feet above ground level.

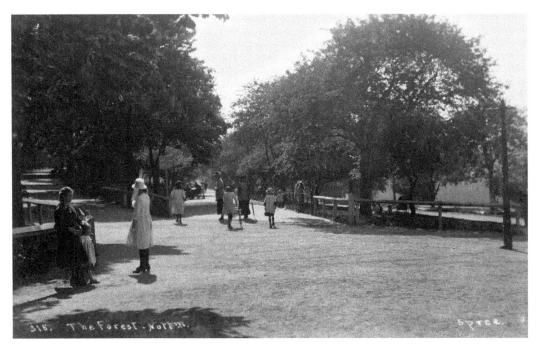

The Forest Recreation Ground is about 1 mile north of Nottingham city centre and is well known as being the site of the Goose Fair. The grounds are bounded by the Arboretum to the south, Forest Fields to the north, Hyson Green to the west and Mapperley Park to the east. (Courtesy of Picture the Past, Nottingham City Council)

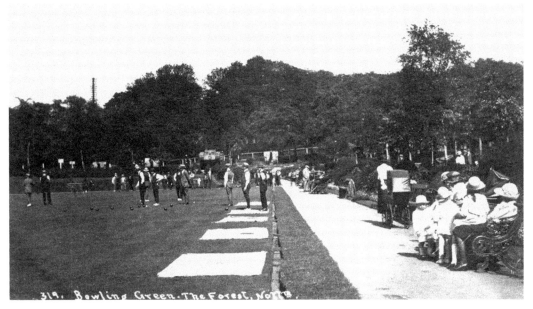

The Forest bowling green. The Forest has also been home to many other sports. In 1865 a team that later became known as Nottingham Forest played their first football game there. Other notable footballing milestones are that in 1872 the first use of the referee's whistle was recorded in a match at the Forest, and that in 1874 Nottingham Forest became the first team to wear shin pads.

Bluecoat School, located at No. 250 Mansfield
Road on Bluecoat Street corner. The Bluecoat School
was founded in 1706 by Timothy Fenton, rector of
St Peter's Church. It was Nottingham's first elementary
school that educated both sexes free of charge.

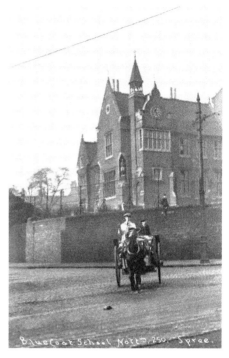

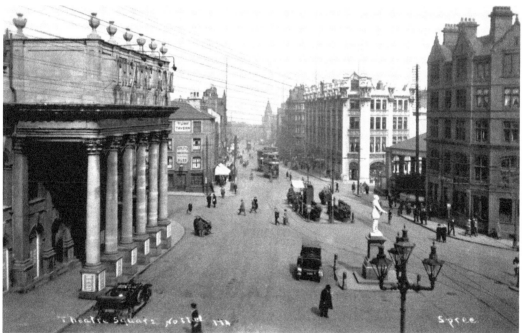

Nottingham Theatre Square in Upper Parliament Street. Looking east, this photograph shows the
Theatre Royal on the left, which opened in 1865, and the Turf Tavern Inn. On the right, the white
building is the Elite Cinema, which opened in 1921. In the centre of the road is the Samuel Morley
statue, which was removed in 1927. The advert on the Turf Tavern is for 'Hooley's Home Brewed Prize
Medal Ales'. (Courtesy of Picture the Past, Nottingham City Council)

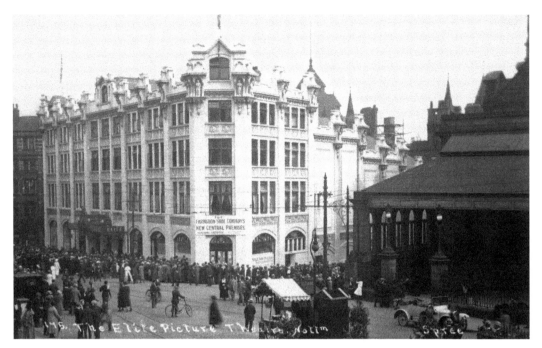

Elite Picture Theatre, Parliament Street. This is a view from the north-east, possibly around the time or shortly after the cinema opened on 22 August 1921 with the showing of Mary Pickford in *Pollyanna*. The corner of the building on Parliament Terrace is used as a shop and advertises the 'Faringdon Shoe Company's New Central Premises'. The post office canopy is shown on the right.

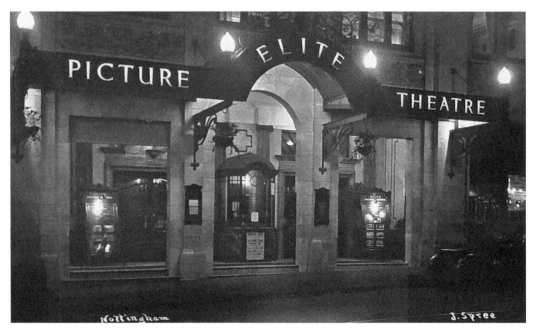

The Elite Picture Theatre's entrance at night. There were plans to demolish the building in 1972, but although they were not carried out the cinema was closed in March 1977 and later became a bingo hall. The building has many interesting features that are of historical architectural interest.

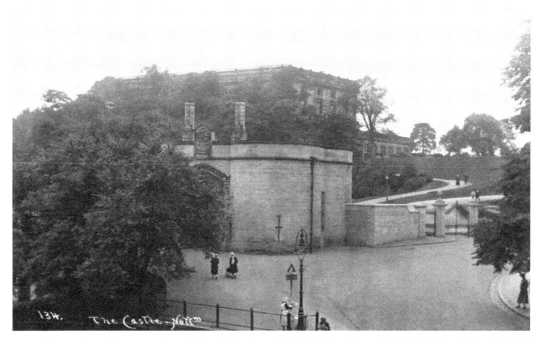

The castle and gateway viewed from Friar Lane. While Richard I was in the Holy Land for the Third Crusade in the late twelfth century, Nottingham Castle was occupied by supporters of Prince John, including the Sheriff of Nottingham. In the legends of Robin Hood, Nottingham Castle is the scene of the final showdown between the sheriff and the hero outlaw.

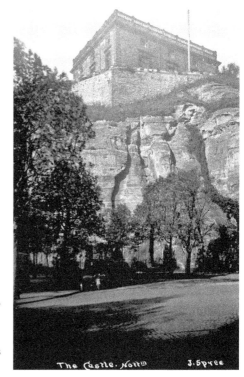

The castle from Castle Boulevard. After the restoration of Charles II in 1660, the present 'castle' (or ducal mansion) was built between 1674 and 1679 on the foundations of the previous structure. The mansion was attacked and set on fire by rioters in 1831.

The grounds of Nottingham Castle. The ducal mansion was a derelict shell for a while, until it was restored and the grounds later landscaped. It was opened in 1878 by the Prince of Wales as the Nottingham Castle Museum, which was the first municipal art gallery in the UK outside of London. (Courtesy of Picture the Past, Nottingham City Council)

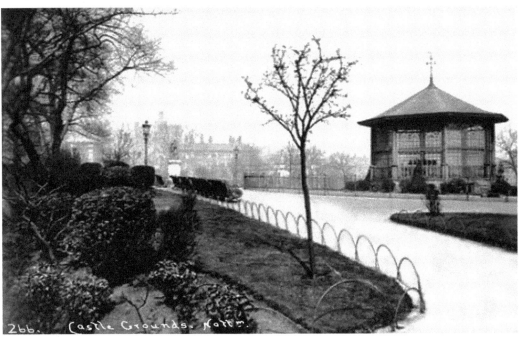

The bandstand on the castle grounds dates to the Edwardian period (1901–10), when the grounds were turned into a park for the people of Nottingham. It was the centrepiece of the gardens and hosted bands while the public wandered the grounds.

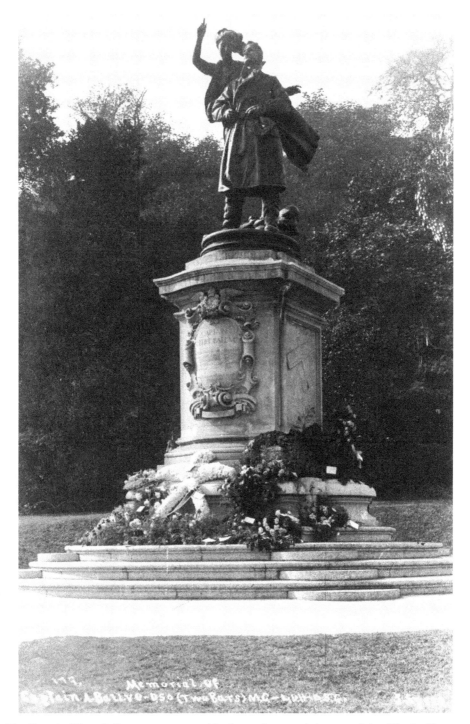

The Captain Albert Ball statue was erected in the castle grounds in 1921. It is a life-sized bronze figure of Captain Ball, who is dressed in his flying kit. Albert Ball was the first Royal Flying Corps winner of the Victoria Cross – awarded for his heroics during the First World War. He died in action on 6 May 1917, aged twenty.

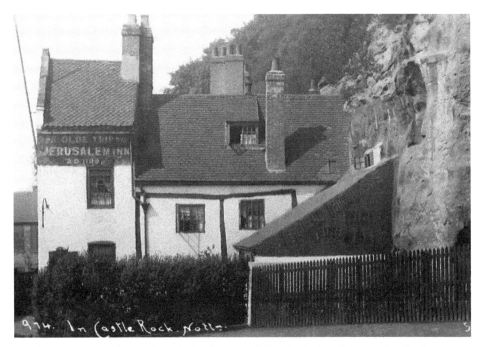

Ye Olde Trip to Jerusalem and Castle Rock on Castle Road. The inn claims to date back to 1189, although this is difficult to verify – the date on its wall in this photograph appears to display '1199' as the establishing date. The inn claims to be the oldest in the world.

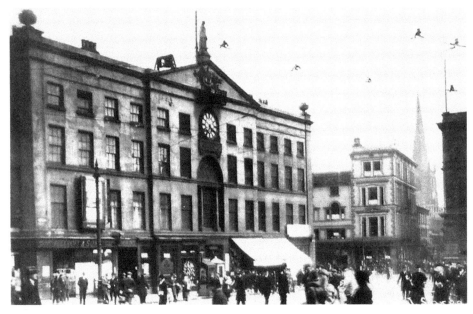

Nottingham Exchange. To the bottom left of the photo is the Beecroft & Son's Toy Shop. On the right corner is Stapleton's shop. The Nottingham Exchange was erected between 1724 and 1726. It cost £2,400 and comprised a four-storey, eleven-bay frontage that was 123 feet long. The architect was Mayor Marmaduke Pennell. The Exchange was demolished in 1926 to make way for the new Council House.

The new Council House, looking north-east. This landmark Nottingham building was designed by Thomas Cecil Howitt and built between 1927 and 1929 in the neo-baroque style, which is characterised by the huge pillars that circle the building along with the carvings on the façade. It replaced the former Exchange and was officially opened on 22 May 1929.

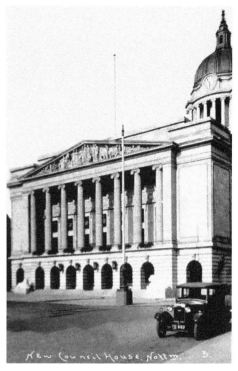

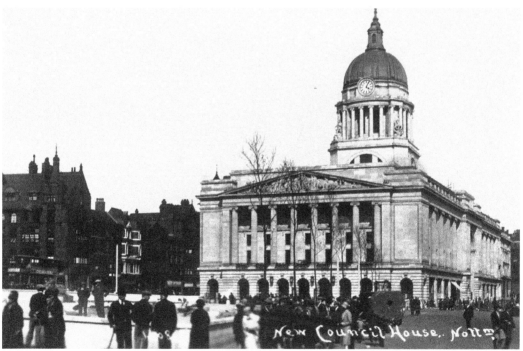

This image is looking north-east from the corner of Old Market Square and shows the west and south façades of the new Council House. The clock on the dome shows that this photograph was taken at 4.10 p.m.

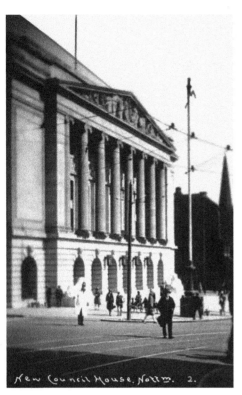

The Council House is seen here looking south-east from Long Row. The terrace has eight massive columns, above which are twenty-one figures representing the activities of the council. The frieze behind depicts traditional local crafts such as bell founding, mining and alabaster carving.

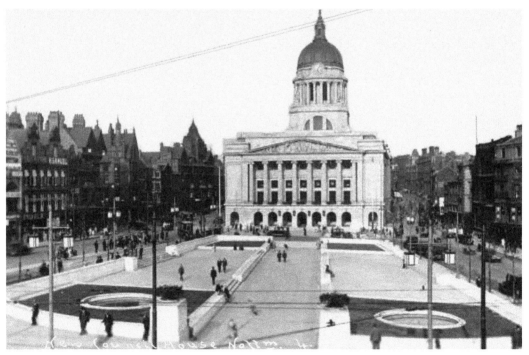

A view east across Old Market Square. The golden ball on the very top of the dome stands 200 feet above the square below. The clock shows this photograph was taken at 6.05 p.m.

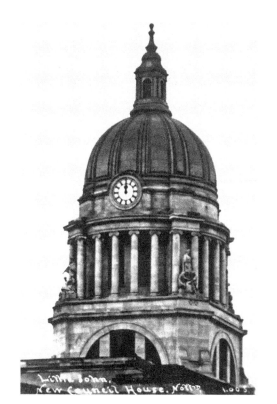

The clock, nicknamed 'Little John', and dome of the Council House. The clock mechanism was manufactured and installed by William W. Cope. The bell was cast in 1927 by the world-famous bell founders John Taylor & Co. of Loughborough.

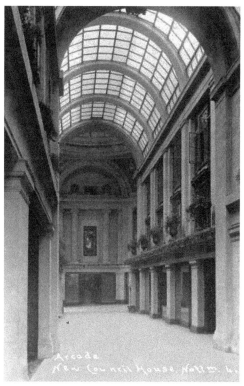

The initial design of the Council House provided for a shopping arcade and office accommodation only. It was not until the council realised it would have to spend further funds on new civic offices and council chamber elsewhere that the design was revised to incorporate them.

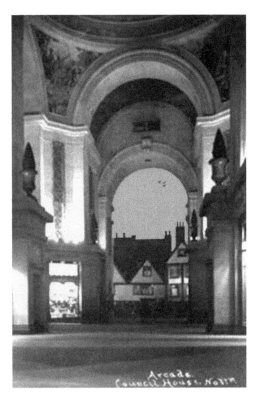

The Council House arcade, which housed a number of the more upmarket retailers, looking south towards Cheapside. The arcade is lit with natural light and has three exits: east onto High Street, south onto Cheapside and north onto Long Row.

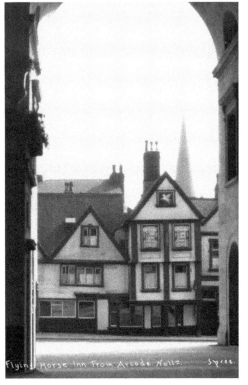

This photograph was taken from inside the arcade and shows the Flying Horse Inn situated on the Poultry. It states on its sign that it was established in 1483. For a while in the eighteenth century it was called the Travellers Inn but then reverted back to its original name. It closed in 1989 and was converted into a shop. In the background is the spire of St Peter's Church.

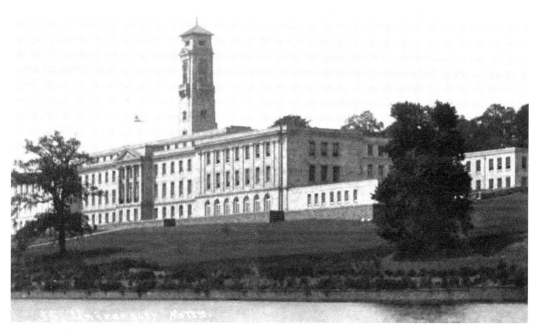

The University of Nottingham's Trent Building. Jessie Boot the chemist offered 35 acres of his estate as a site for the university and 220 acres to be laid out as a pleasure park for the benefit of all in Nottingham. The building project included a new road between Nottingham and Beeston and the enlargement of the existing water pond to create a boating lake.

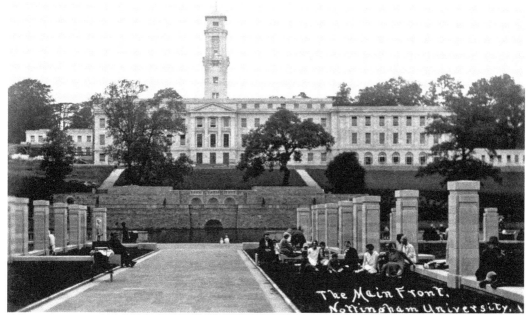

The Trent Building's front elevation, looking from the university's main entrance on the new University Boulevard. University College Nottingham was initially accommodated within the Trent Building, which was formally opened by George V on 10 July 1928. During the early period of development the University of Nottingham attracted high-profile lecturers including Albert Einstein, H. G. Wells and Mahatma Gandhi.

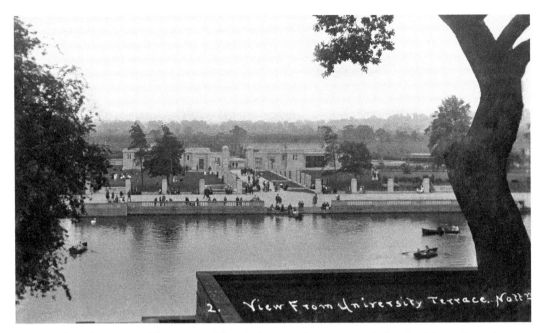

The view from the terrace of the Trent Building, looking south-east across the boating lake to the main entrance on University Boulevard. In the distant background the tree-lined embankment of the River Trent can be seen in Wilford. (Courtesy of Picture the Past, Nottingham City Council)

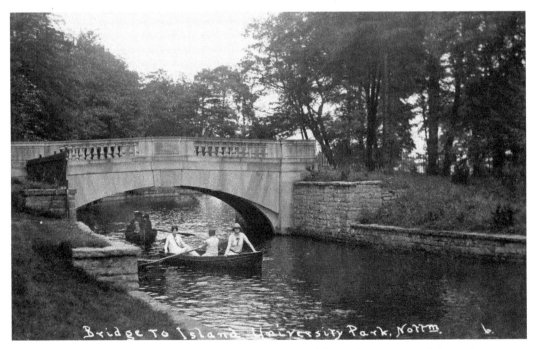

One of the ornamental bridges to the largest island in the boating lake on the University of Nottingham's campus. The photograph is taken from the path on the south side of the lake, near to Tottle Brook. The island is linked to both the north and south shores by the two balustraded bridges. (Courtesy of Picture the Past, Nottingham City Council)

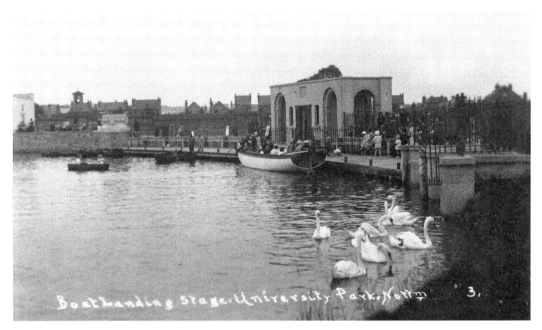

The University of Nottingham's boating stage. From the gate on University Boulevard a paved walk leads over a bridge across the Tottle Brook and turns left and right to encircle the lake. This large landing stage is located on the eastern shore of the lake. (Courtesy of Picture the Past, Nottingham City Council)

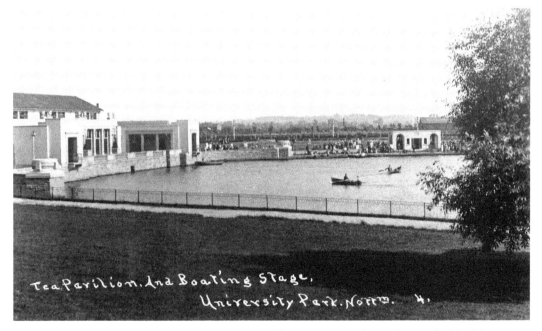

The University of Nottingham's Tea Pavilion and boating stage at the northern end of the lake, set in a level area of car parking and lawns. Opening in 1925 as the Tea Pavilion, it had regular dances inside and bands often used to play outside for the customers on a Sunday. (Courtesy of Picture the Past, Nottingham City Council)

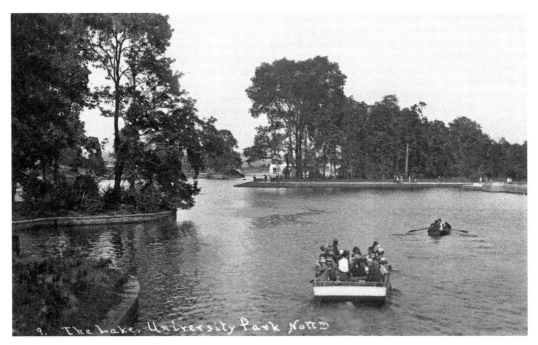

University Park. Sir Jesse Boot's Property and Development Company used its own staff to maintain the grounds, supervise the sports facilities and manage the catering for the Tea Pavilion until the city council formally adopted the park in 1932. (Courtesy of Picture the Past, Nottingham City Council)

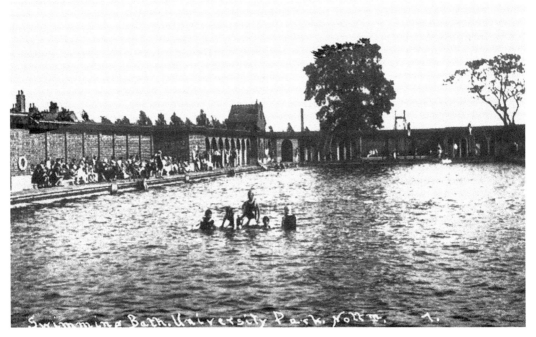

University Highfields Lido, located at the eastern end of East Drive and opened in August 1924. The water for the lido was originally fed directly from the lake and had to be emptied once a week. The council thought this was unhygienic and when they took over the park they installed a filtration system.

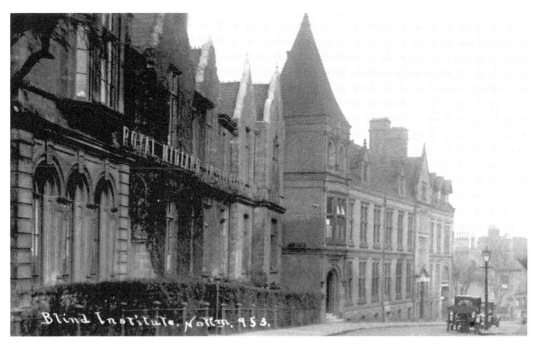

Royal Midland Institution for the Blind, located at No. 30 Chaucer Street, was established in 1843. It was built in a Jacobean Revival style of architecture with an extension to the right-hand side of the building in the early 1900s. (Courtesy of Picture the Past, Nottingham City Council)

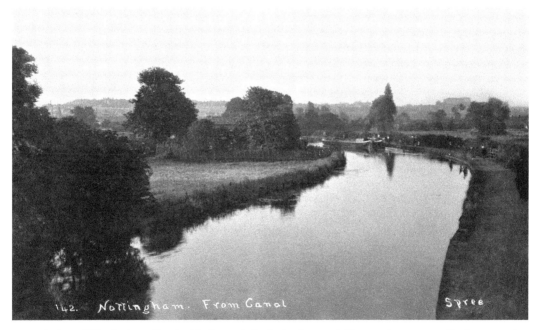

A view of Nottingham Canal with the castle in the background. The canal was 14.7 miles long, running between Langley Mill in Derbyshire and Nottingham where it connected to the River Trent at the Meadow Lane Lock. Very little now remains of the canal, which went into decline from around 1923. (Courtesy of Picture the Past, Nottingham City Council)

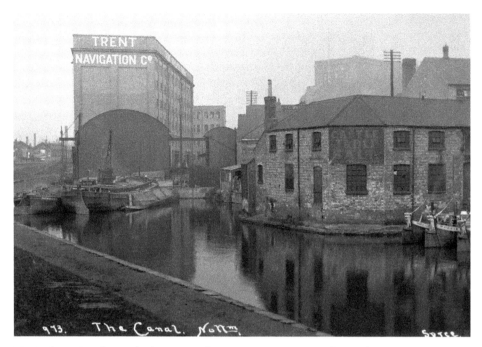

Nottingham Canal, seen looking west from Carrington Street. The castle can be seen in the background. The Trent Navigation Company was established in 1783 and ceased to exist in 1940. Shown on the warehouse to the centre right of the photograph is an advert for 'Castle Table Salt'. (Courtesy of Picture the Past, Nottingham City Council)

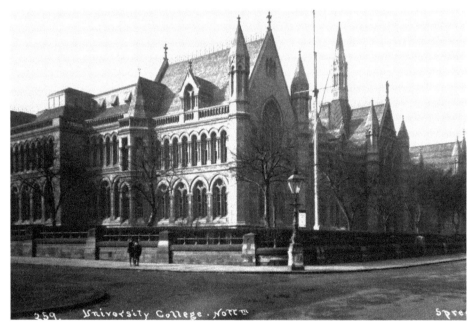

University College, Shakespeare Street. Building work began on the new college in 1877 and was funded by an anonymous donation. The foundation stone was laid on 27 September 1877 and the college opened for classes in 1881.

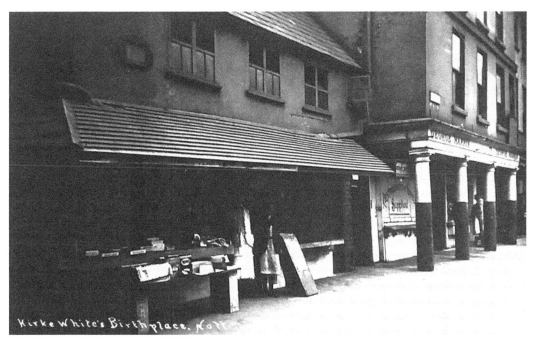

The birthplace of Henry Kirke White, a renowned poet born on 21 March 1785 at his father's butcher's shop in the Shambles – next to where the Exchange Walk Arcade is on Cheapside. He died at the young age of twenty-one on 19 October 1806.

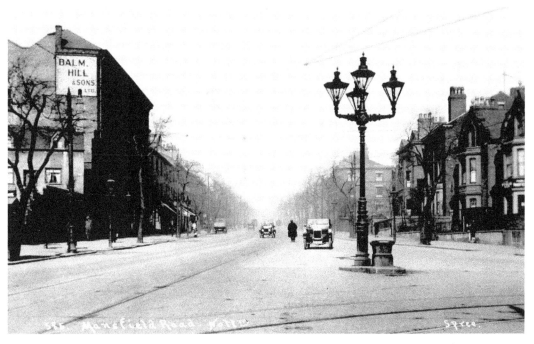

Mansfield Road, looking north just past the junction of Woodborough Road on the left. The premises of Balm, Hill & Sons (lace manufactures) can be seen on the left of the photograph. The company registered a patent for a pattern of lace in 1884.

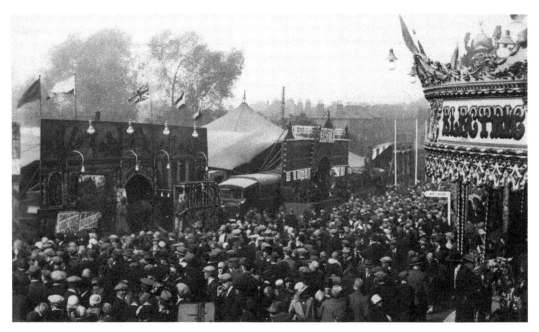

The Goose Fair. This is believed to have started just after 1284 when a charter granted by Edward I authorised the burgesses of Nottingham to hold fairs. It was moved from its site at the centre of town (in the Market Square) to its current location at the Forest Recreation Ground in 1928.

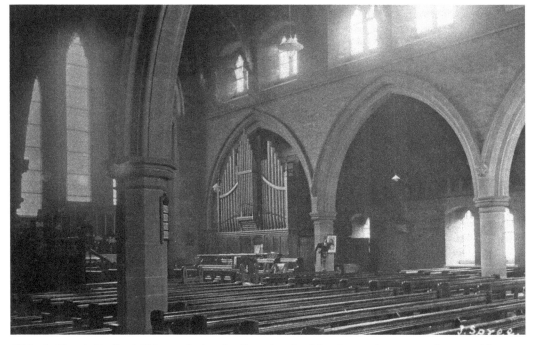

All Souls Church, Radford. This was the last Anglican church of the nineteenth century to be erected in Radford. The design of the church was never fully implemented due to a lack of funding. In November 1892 the foundation stone for the new church was laid at the corner of Ilkeston Road and Lenton Boulevard. The church was consecrated in 1896 and was demolished in 1979.

Oxton

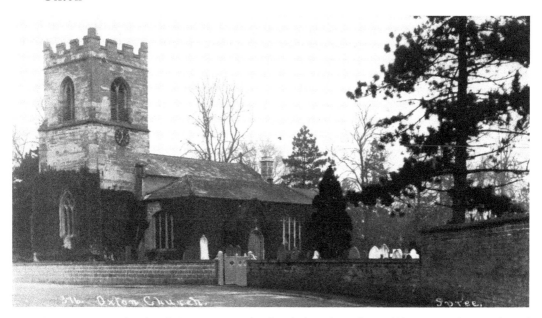

St Peter & St Paul's Church, Main Street. The church dates from the twelfth century. The east chancel window was reglazed as a war memorial containing the names of the villagers who died in the First World War; it was dedicated in 1921.

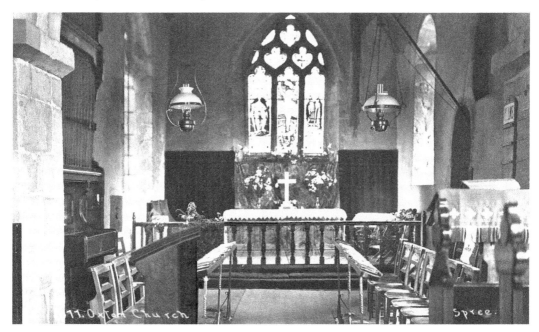

St Peter & St Paul's Church, showing the chancel and the memorial window. On the left panel is a figure of St George; the centre panel shows the Crucifixion above a fallen soldier in a First World War uniform; and the right panel has a figure of St Nicholas. Below the three figures are the names of those inhabitants who died in the First World War.

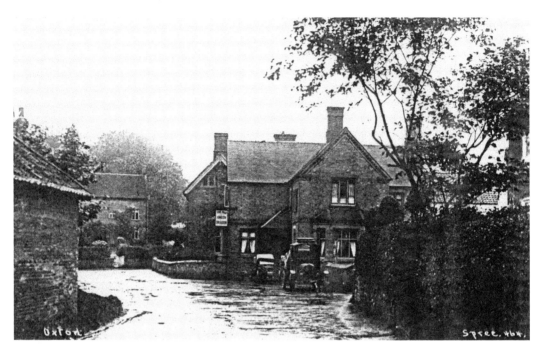

The Old Green Dragon, Blind Lane. This pub was well known and drew in carriage-borne customers from the surrounding area. Until the 1920s the pub was part of a dairy farm, whose surrounding farm buildings were demolished to make way for the car park.

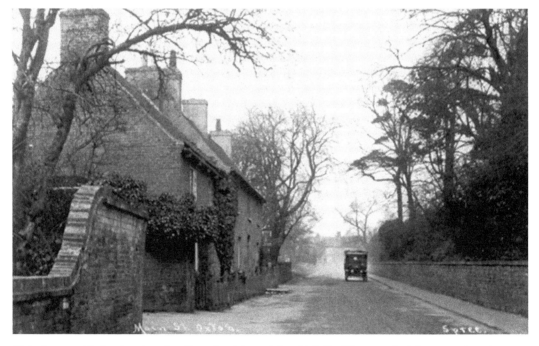

Main Street, with the churchyard wall on the right and the old Police House to the left, approximately 300 feet north of the church. There was a cottage to the rear of the Police House and a well in the garden for domestic water.

Plumtree

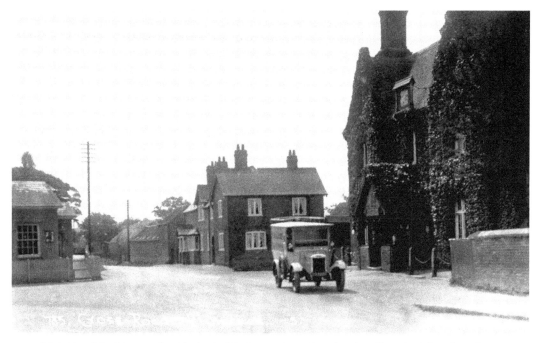

Main Road, looking south with the Griffin Inn on the right, Church Hill on the left and Bradmore Lane on right. The pub was built in 1843, replacing another pub – the Plough – on the same site. The village school to the left was constructed in 1840.

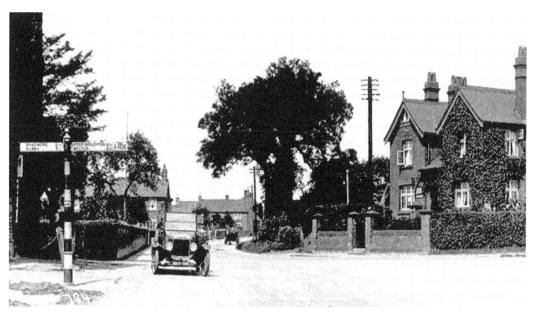

Plumtree Crossroads, looking north along Main Street with the Griffin Inn on the left and the post office on the right. The signpost gives directions and distance to Upper Broughton and Melton to the right, with Bradmore and Bunny to the left.

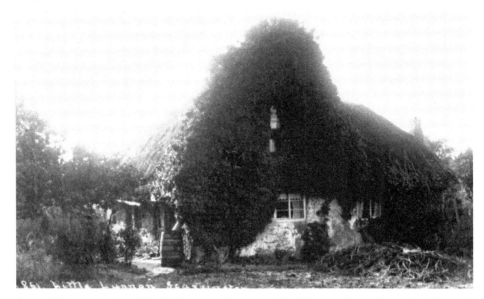

Around fourteen mud and thatched cottages known as 'Little Lunnon' were located on the south side of Scarrington village. Originally built as the village poorhouses, these were constructed on waste or common land a short distance away from Scarrington. (Courtesy of Picture the Past, Nottingham City Council)

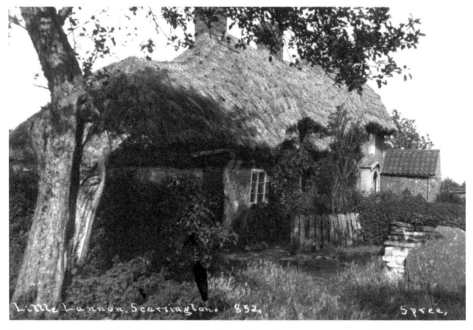

The cottages were believed to date from the eighteenth century. Seven of the cottages were demolished in 1814 and then further ones until the final two in 1945. Water was obtained from a single well, which was 7 feet deep – even up to the time of demolition there was never any piped water or sanitation.

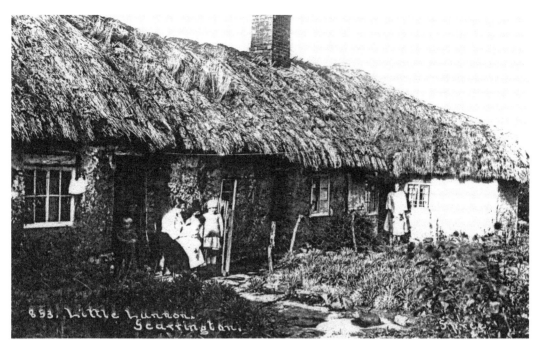

Each cottage consisted of one room downstairs and a bedroom above, the latter being reached by means of a ladder passing through a trapdoor in the ceiling of the living room. The mud and straw walls were substantial, being 18 inches in thickness, while the roofs had a thick covering of mud and thatch.

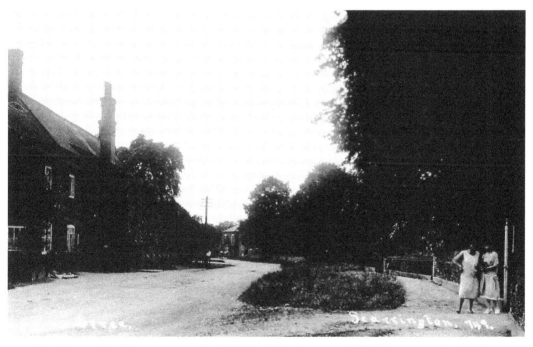

Scarrington, showing cottages on the left side of the photograph. This image was taken looking west along Main Street, approximately 300 feet from the junction with the Hawksworth Road. Two ladies are standing outside the railings to the property on the right.

Screveton

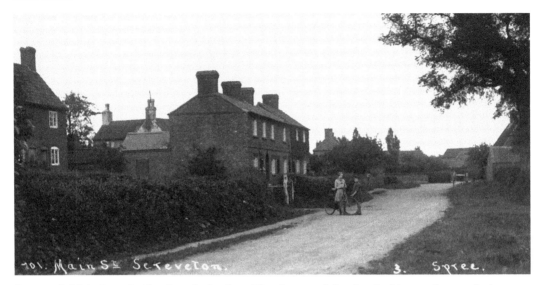

Screveton's Main Street leading from Spring lane. The photograph is taken looking north towards the junction with the Hawksworth Road. The traffic-free unmade road looks ideal for the youngsters to go bicycle riding.

Sherwood

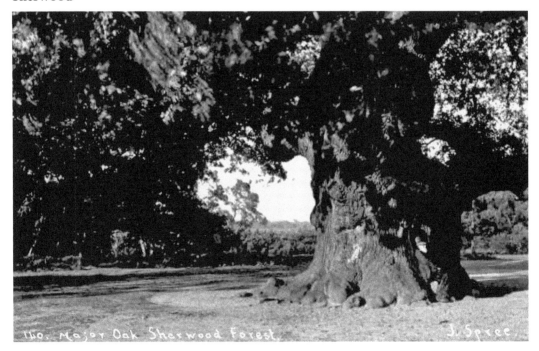

Sherwood Forest, Edwinstowe. The Major Oak is a large English oak, and according to legend it was the shelter of Robin Hood his Merry Men. The tree is between 800 and 1,000 years old. Note the old man sitting on the trunk of the tree.

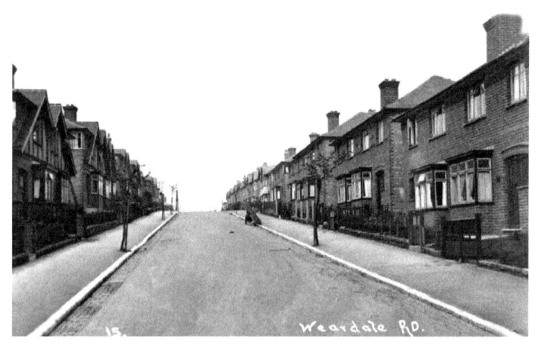

Weardale Road, seen looking west up the hill from the Teesdale Road and Hucknall Road end. Weardale Road is approximately 1.75 miles north from the centre of Nottingham and is around 250 yards in length with mainly semidetached properties.

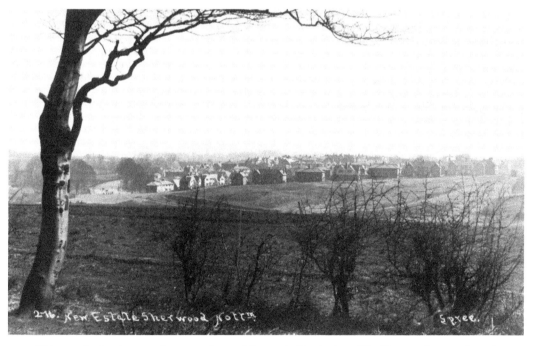

This was the first large-scale estate of council houses in Nottingham. The Sherwood estate of 557 houses north of Woodville Drive was completed by August 1922. The estate was extended east of Edwards Lane with a further 108 houses that were built between April and October 1922.

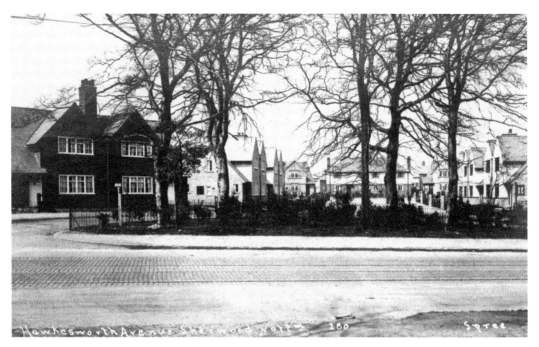

Hawksworth Avenue. The photograph was taken looking north-west at the Spinney on Mansfield Road. The avenue starts beyond the Spinney and continues to Montfort Crescent. The avenue is short, housing just eight properties. The tramlines running along Mansfield Road are part of the 1915 Arnold extension of the 1902 tram route, which ran from the marketplace to Winchester Street.

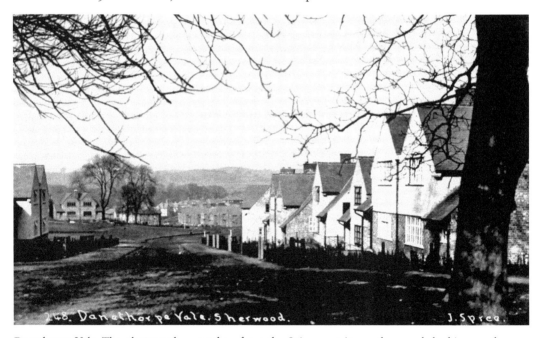

Danethorpe Vale. The photograph was taken from the Spinney at its southern end, looking north towards Staunton Drive. Danethorpe Vale connects Mansfield Road in the south to Valley Road in the north and is approximately 0.45 miles long.

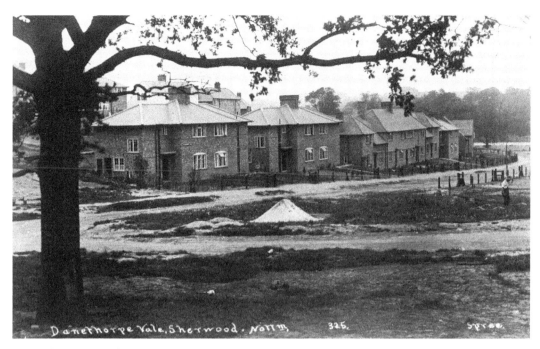

The junction of Bonnington Crescent with Danethorpe Vale in front of the houses continuing to the junction of Valley Road in the far right of the background. The properties on the eastern side of the road have not yet been constructed.

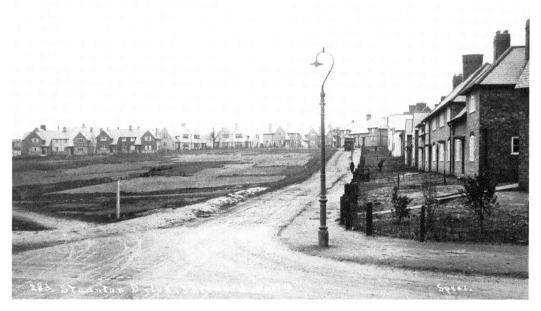

Staunton Drive. A winter's day with a dusting of snow settled on the ground and the roofs of the houses. The photograph is taken from the junction of Danethorpe Vale and is looking north-east to Montfort Crescent, seen in the background. The area is under construction with plots on the left laid out for further development.

Skegby

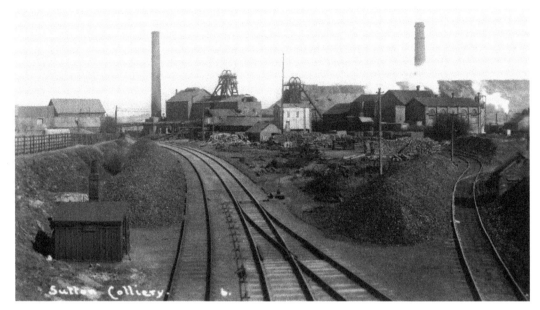

Sutton Colliery, located near the village of Skegby. Two shafts, each 15 feet in diameter, were sunk in 1874 by the Skegby Colliery Company and deepened during 1896 to 1897 to the lower seam at 467 yards below the surface. It closed in 1989.

Teversal

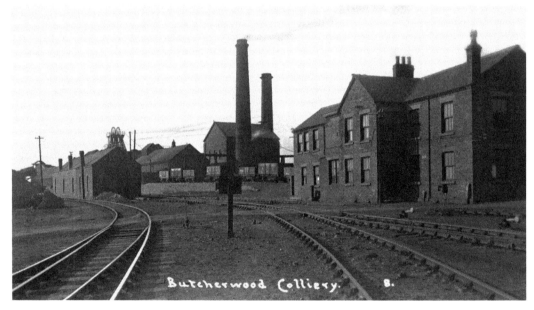

Teversal Colliery. This was commonly known as Butcherwood as it was in the former woodland known by that name. The colliery was sunk between 1862 and 1867 by the Stanton Ironworks Co. Ltd. The new colliery brought in miners from other counties to work there. The pit closed in 1980.

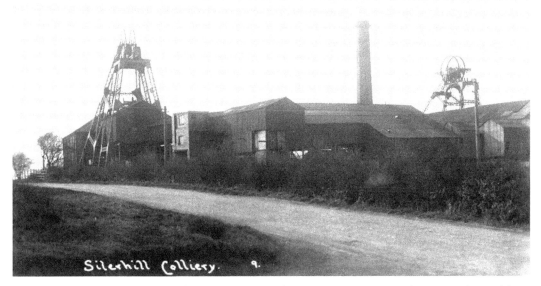

Silverhill Colliery, owned by the Stanton Iron Co. began operation in 1875. This attracted more labour from outside the area and, to cater for that and for the other pits in the area, the Stanton Company built housing in the area of Skegby. This housing later became known as Stanton Hill. The colliery closed in October 1992.

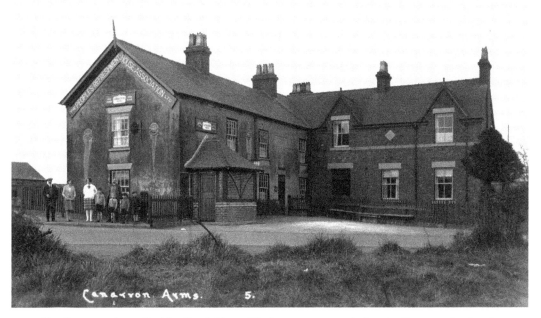

The Canarvon Arms, Fackley Road. The public house was named after the Canarvon family who were lords of the manor until 1929. The banner on the wall shows that the inn was run under the auspices of the Peoples Refreshment House Association, which encouraged moderation in drinking alcohol.

Upper Broughton

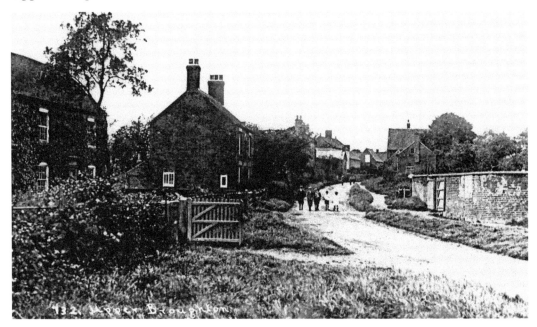

A view of Bottom Green, looking west and approximately 230 feet from the junction with Melton Road. Bottom Green is the lower of two lanes from the Melton Road that lead into the village, the other at a higher level is appropriately called Top Green.

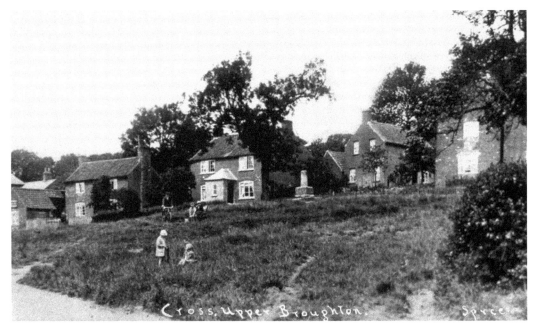

The village cross. The photograph is taken from Bottom Green looking north, with the cross near to the junction with Top Green on the left. The cross is said to have been placed there as a 'thank you' offering because the Black Death passed by the village.

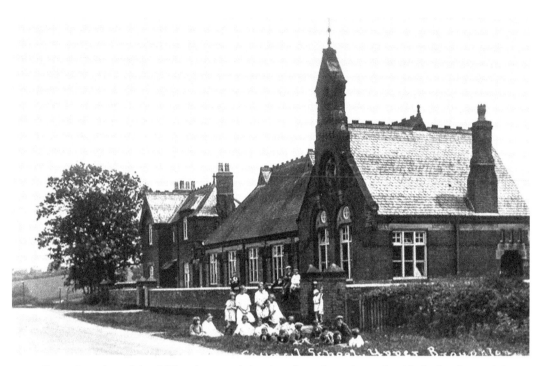

Upper Broughton School. The photograph is taken from the main road, with the headmaster's house at the far end. The school opened in 1877, taking both infant and junior pupils, and could house up to 150 children. It closed in 1969.

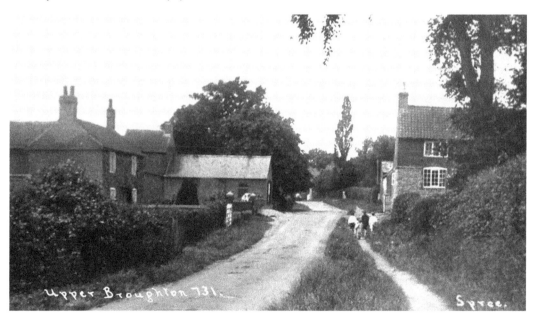

Looking west along Station Road, approximately 140 yards along from the junction of Top Green and Bottom Green. Bailey's the butcher's shop is on the left-hand side across the road from the cottage. Bailey & Sons were established in 1905 and were one of the founder members of the Melton Mowbray Pork Pie Association.

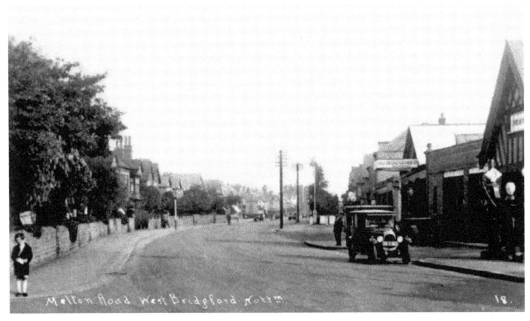

Melton Road, West Bridgford. The garage to the right of the photograph was owned at this time by W. W. Shepherd. The petrol pumps in front of the garage show that the garage sold 'National Benzole Mixture'. It was demolished in 2003.

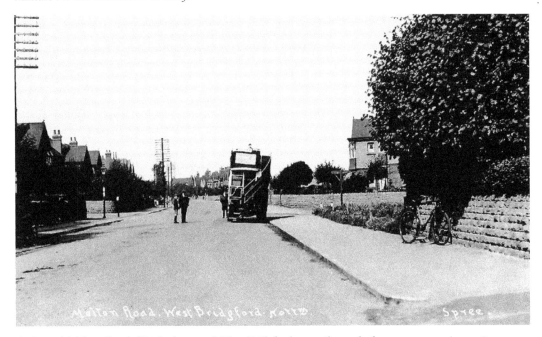

A view of Melton Road. Nottingham and West Bridgford councils reached an agreement in 1928 to operate joint bus services between the city and the town of West Bridgford. This agreement remained in place for forty years. The bus in this image has a sign 'via Musters Road' and is probably the No. 11 service.

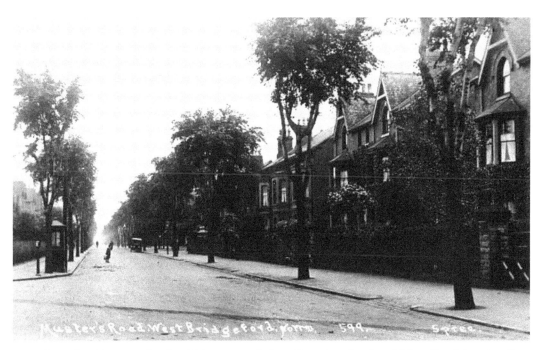

A tree-lined Musters Road, which runs north from Boundary Road to Melton Road for virtually a straight mile. An example of an early telephone box can be seen on the left. Notice the different spelling of Bridgford.

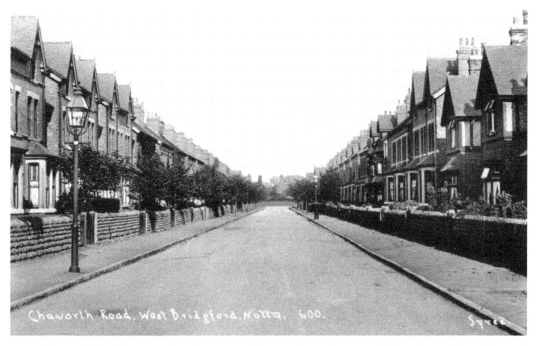

Chaworth Road is approximately 500 yards long and runs between the junctions of Loughborough Road in the south-west and Musters Road in the north-east. This photograph is taken from approximately midway along the road, looking north-east.

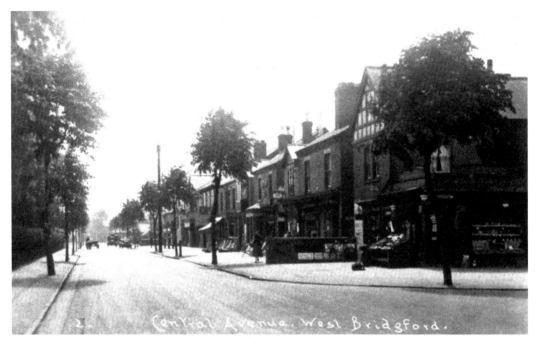

Central Avenue, looking south-east from the junction with Bridgford Road. The shop on the corner is a grocery store and post office, which was owned by Richard Herbert Blount. Further down on the right-hand side is the Avenue Garage, which sold the Cleveland brand of petrol.

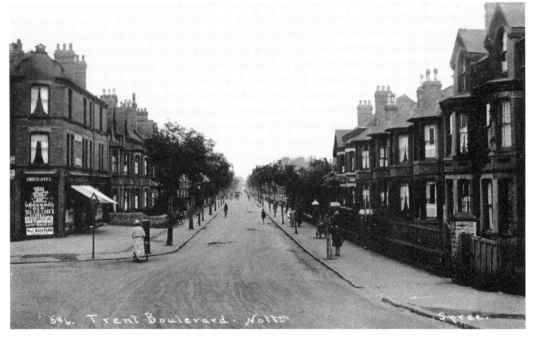

Trent Boulevard runs in a straight east–west line from Adbolton Lane to Radcliffe Road in the Lady Bay area, and is approximately 0.7 miles long. This photograph is taken from the junction of Holme Road and Radcliffe Road, looking east.

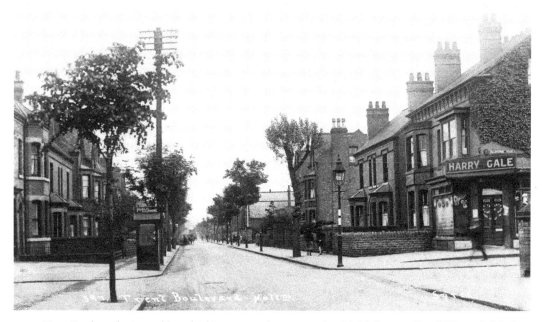

Trent Boulevard, pictured here looking east at the crossroads with Melbourne Road. Harry Gale's shop on the corner has adverts for Player's Country Life cigarettes, Oxo and Coleman's mustard. Opposite the shop is a public telephone box.

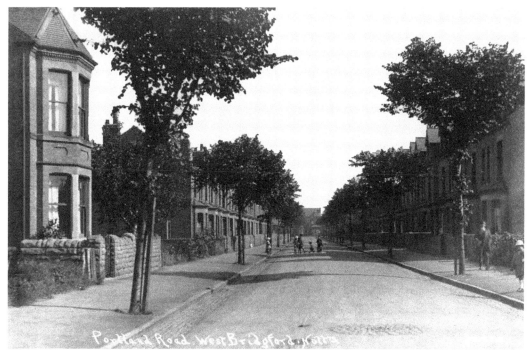

Portland Road, which runs east to west between Melton Road and Exchange Road, is approximately 300 yards long. This photograph is taken looking west to Exchange Road from just past the junction of Annesley Road on the left.

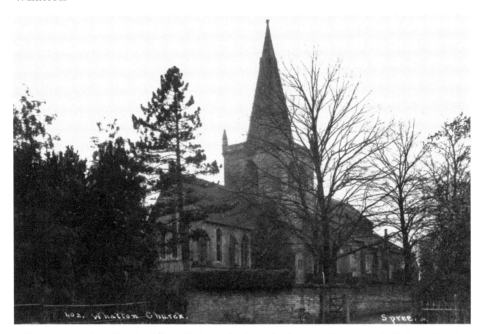

St John of Beverley Church. Although dating back to the fourteenth century, little from then has survived and restorations were undertaken in the nineteenth century. It now consists of a chancel that was rebuilt in 1846, a central tower and steeple that was rebuilt in 1870, and a nave with north and south aisles and north and south porches.

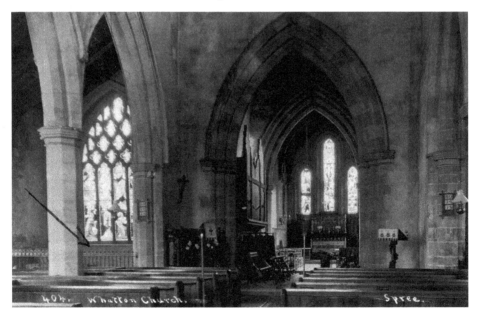

The interior of the Church of St John of Beverley. The sender of this card marked it with an arrow to show the location of the reclining figure of Sir Richard de Whatton at the west end of the south aisle, who died around 1336.

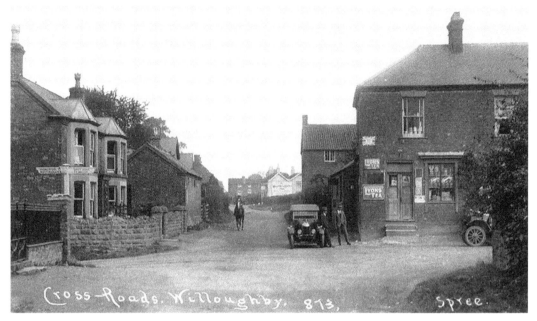

The crossroads on Main Street with Widmerpool Lane on the left and London Road on the right. Note the Lyons tea adverts on the wall of the shop. The car belongs to the photographer and is a Bullnose Morris Cowley.

Monuments in All Saints' Church. On the north side of the church is the Chapel of St Nicholas, which is filled with monuments of departed members of the house of Willoughby. The sender of this card has written on it 'Sir Richard de Willoughby'.

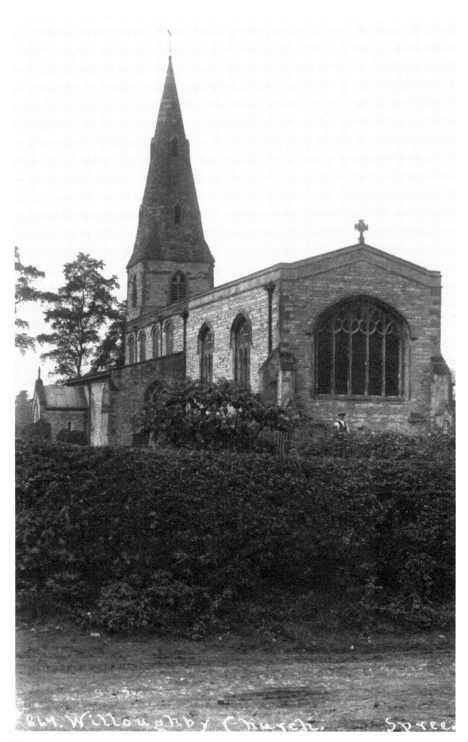

All Saints' Church, which dates back to the thirteenth century. Major restoration and enlargement took place in 1781 when the chapel was repaired, in 1829 with general repairs and enlargement, in 1891 when the chancel was rebuilt, and in 1908 with general restoration and when the porch was built.

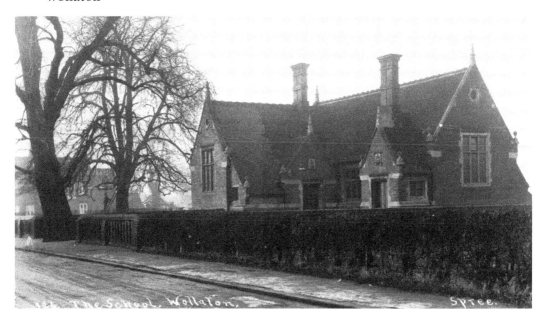

Wollaton School, located at No. 8 Bramcote Lane near Smithson Drive. The photograph was taken looking south-west. The school was originally opened in 1841, but the building seen here dates from 1865 and was enlarged in 1894 by Lord Middleton.

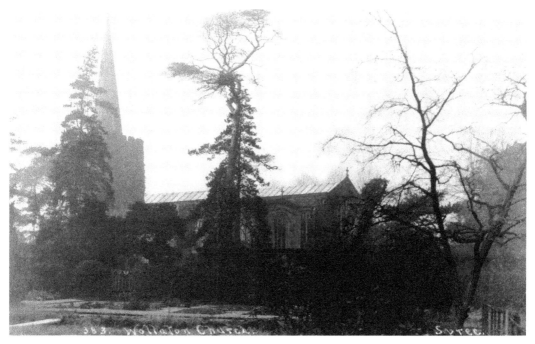

St Leonard's Church is on Wollaton Road near the Admiral Rodney public house. St Leonard's dates from at least the early thirteenth century, the chancel being the earliest part, with the nave and tower dating from the fourteenth century.

St Leonard's Church contains three war memorials, with this one being in a prominent position at the entrance. The memorial is to those who served in the First World War and is set externally at ground level against the west wall of the north aisle. The memorial lists seventy-three names.

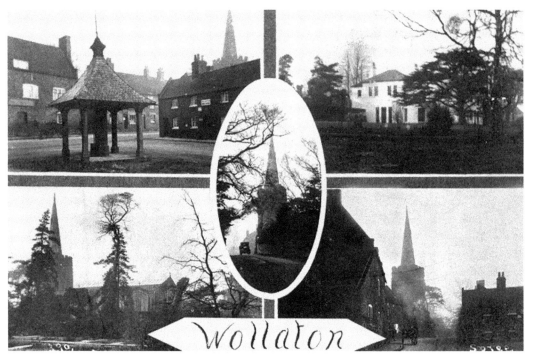

A multi-view card showing two images of St Leonard's Church on Wollaton Road, the Rectory on Rectory Avenue, and the village pump, which stands outside of the Admiral Rodney pub at the junction of Wollaton Road and Bramcote Lane.

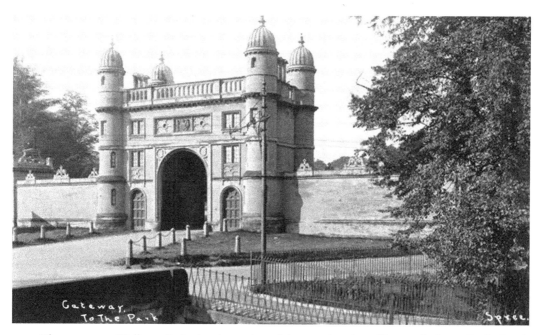

The gateway to Wollaton Park, showing a view of the east elevation of Lenton Lodge on Derby Road. The lodge is one of the finest gatehouses in Britain. The iron-bound gates with their underground mechanical opening system are a feature of the building.

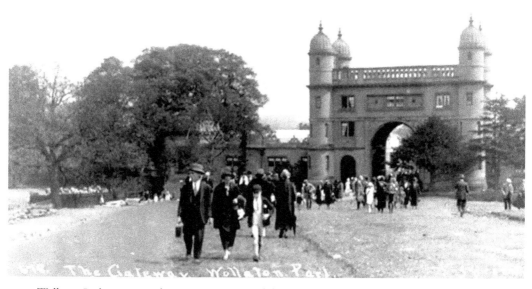

Wollaton Park was opened on 22 May 1926 and the gates at Lenton Lodge were opened at 3 p.m. It was originally a gateway to Wollaton Park but became separated in the late 1920s by housing development.

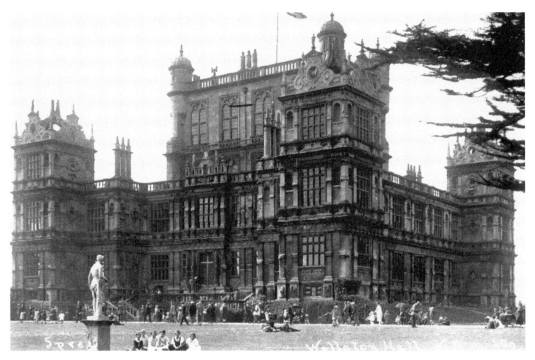

Wollaton Hall, built between 1580 and 1588, is considered to be the most important Elizabethan house in Nottinghamshire and one of the most important in England. The material used in its construction is Ancaster stone from Lincolnshire, which was exchanged for coal from the Wollaton Pits.

Although captioned as being 'Elm Avenue', this is actually Lime Tree Avenue, which starts in the east at the entrance gates on Middleton Boulevard and runs in a straight line for approximately 1,000 yards in a westerly direction towards the front lawns of Wollaton Hall. (Courtesy of Picture the Past, Nottingham City Council)

2. Garden. Wollaton Park. Notts.

Camellia House is one of the earliest cast-iron glasshouses in the country. Built in 1827, it was commonly called the Conservatory and lies approximately 110 yards south-west of Wollaton Hall. The interior is laid out with paths for the public to view the plants.

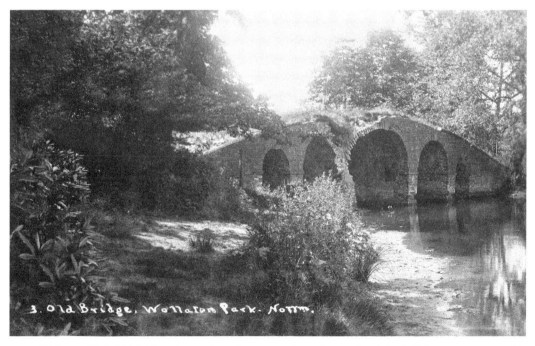

3. Old Bridge. Wollaton Park. Nottm.

Wollaton Hall Old Bridge. Approximately 430 yards to the south of the hall is a 44-acre, roughly triangular lake. This was created between 1774 and 1785. The brick boathouse by the southern shore was designed to look like a classical bridge. (Courtesy of Picture the Past, Nottingham City Council)

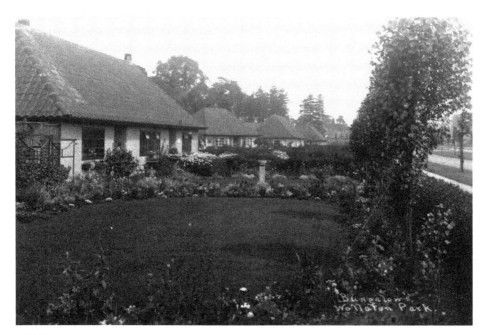

Middleton Boulevard runs from Derby Road in the south to Wollaton Road in the north, forming the spinal road to the Wollaton Park estate. This photograph shows bungalows on the western side looking northwards towards Wollaton Road.

Woodborough

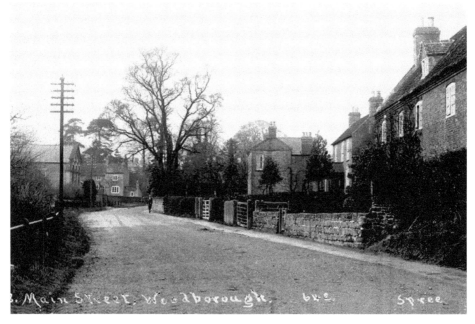

Seen here on Main Street is Johnson's Square shop, selling household goods, on the extreme right. Further up and on the left, towards the western end of Main Street, the Primitive Methodist Chapel can be seen. Just past the chapel is the village blacksmiths.

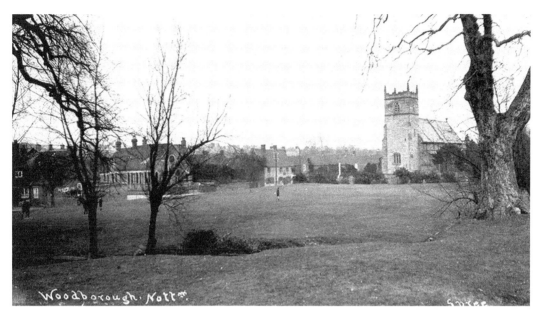

A view looking north from Governors' Field, which is at the junction of Main Street and Lingfield Lane. From left to right is the Four Bells public house, Wesleyan Chapel, the Bugle Horn public house and St Swithun's Church.

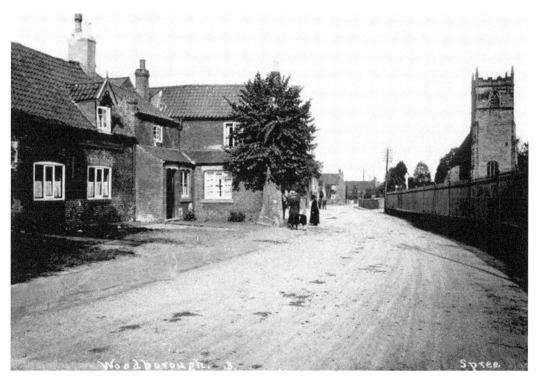

Main Street, looking east. St Swithun's Church is on the corner of Lingwood Lane, which leads to Lambley village. The Four Bells public house is on the left. On the right are the railings to Governors' Field and in the distance is the Punch Bowl Inn.

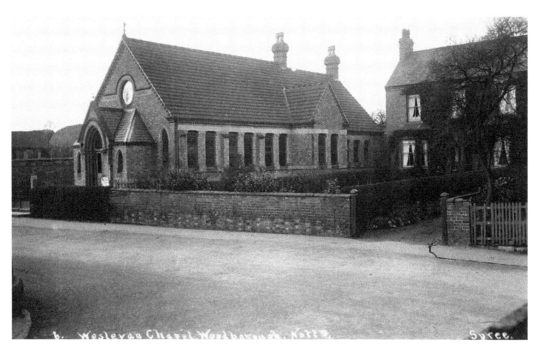

The Wesleyan Chapel is located at the corner of Main Street and Roe Lane. The chapel was built in 1887 and later became the Methodist Chapel. On the right of the chapel is Victoria Villa, which was later renamed as Davenport House.

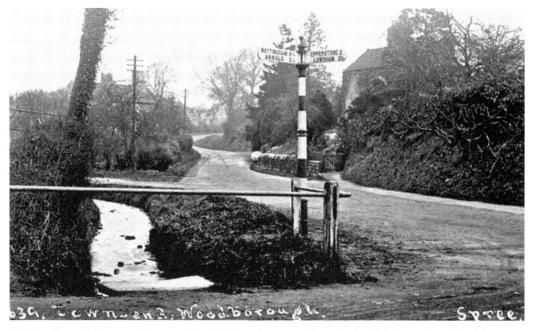

The junction with Foxwood Lane and Bank Hill was known as Town End, which is seen here. The dyke from Westfields can be seen as it approaches the Main Street dyke. The signpost indicates the direction and distances to Nottingham, Arnold, Epperstone and Lowdham. Snow is on the ground and the dyke appears partly frozen.

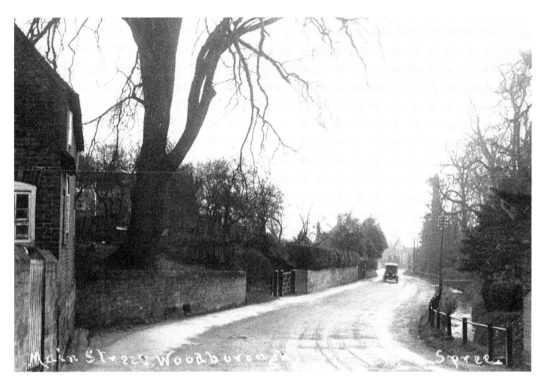

The western end of Main Street, looking east. The building 'Chimneys' is shown on the left. The Chimneys dates from the late eighteenth century and has numerous chimney stacks visible from the road – hence the name. Woodborough Dyke is seen on the right running parallel to the road.

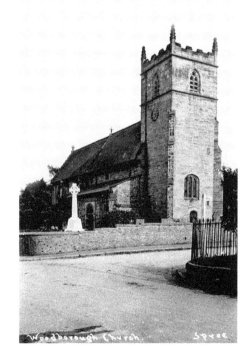

St Swithun's Church is medieval, with the chancel dating from the fourteenth century. The clock was installed by Reuben Bosworth in 1856. The photograph was taken looking south-east from outside the Four Bells public house.

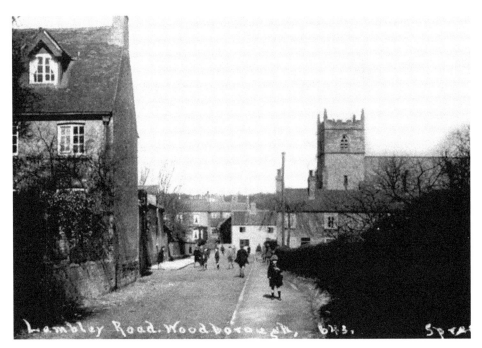

Lingwood Lane, looking northwards to the junction with Main Street. This section of the lane has previously been known as Church Lane, School Lane and Lambley Lane. The lane from the vicarage towards Lambley was also known as Lingwood Hedge Lane.

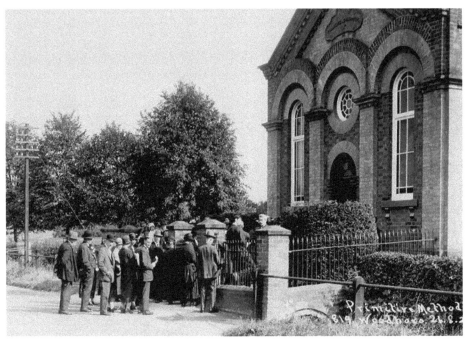

The Primitive Methodist Church was sometimes known as the 'West End Chapel' because of its location in Main Street. It was opened in October 1851 and was extended in 1871 with a rostrum and an organ installed. In 1900 it was enlarged and a schoolroom was added.

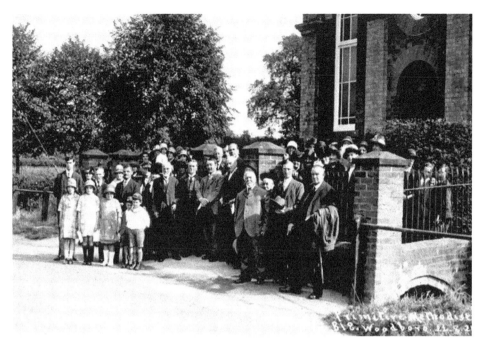

In 1926 a thorough renovation of Primitive Methodist Church took place. A central heating system was installed and a new Communion rail was put in. This photograph is of the congregation gathered outside of the church on 28 August 1926 for the celebration of the new heating system.

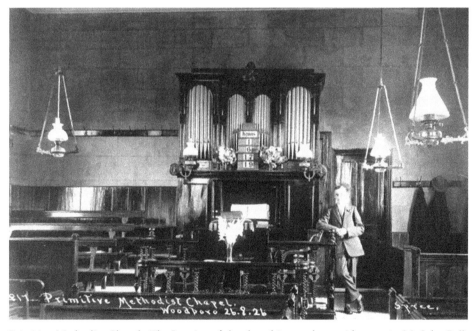

Primitive Methodist Church. The Interior of the chapel is seen here with organist Mr John Ball. The order of hymns is 1, 6, 17 and 19: 'Before Jehovah's awful throne; Lord', 'Thou hast searched and seen me through', 'The spacious firmament on high' and 'Father, how wide thy glory shines'. In 1932 electric lighting was installed and in 1962 the church was closed.

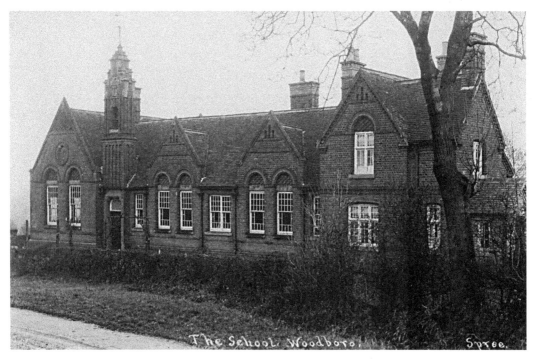

The Woods Foundation School. After the original school, which was part of the old vicarage, was deemed unfit for purpose funds were raised to build a new school on Lingwood Lane. The new school opened in 1878 and lasted until 1968 when another new school replaced it.

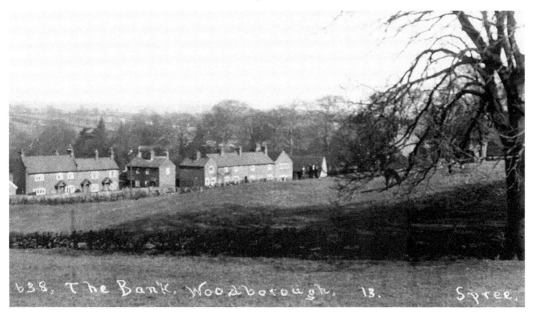

This view of Bank Hill is looking north-east to the frame-knitters' cottages from a field opposite. Framework knitting of stockings developed as a widespread domestic cottage industry during the eighteenth and nineteenth centuries. In 1589, William Lee, a clergyman then living in Woodborough, invented the stocking frame.

Woodborough Hall at the junction of Bank Hill and Main Street. There are records of a hall being on the current grounds dating back to 1086. The present building was built in 1660. A Mr and Mrs Mansfield Parkyns bought the hall in 1852 and carried out substantial improvements and renovations, as seen here.

Methods Used by John Henry Spree to Take, Develop and Print His Postcards

John Henry Spree initially used a dry-plate camera during his introduction to photography and then quickly moved on to a roll film format. My father has stated that John Henry used Kodak cameras, although there is no evidence that this was the case in his early career. However, on that basis it is thought that he would have used the first postcard format camera: the Kodak Eastman 3A Folding Pocket Camera.

In 1888, George Eastman coated gelatine dispersed silver halide crystals onto celluloid sheets to produce a roll film. By the next year, Eastman had commercially produced a camera for the use of rolls of films. The roll film used by many postcard publishers is the Kodak 3A, or later called No. 122 film, which is a postcard format and gives 3.25 × 5.5 inch prints. It was made by Kodak and produced between 1903 and 1971. Photographic roll films in the period that John Henry Spree was publishing his postcards were generally orthochromatic, which means that they were sensitive to all visible light except red. Prior to this, the early photographic materials were sensitive to blue light only, but orthochromatic materials extended this to green, which is also the colour our eyes are most sensitive to, so this greatly improved the tonal rendition of photographs. However, blue skies – perhaps with interesting cloud formations – appeared on the photograph as shades of white. This can be seen on many of John Henry Spree's postcards.

Once the film had been exposed to light through the camera's aperture being opened, it had to be developed. Because orthochromatic film is insensitive to red light, John Henry Spree would develop it in his darkroom with a red safe light switched on. Roll films would be manually 'see-sawed' up and down through a developer solution in a shallow dish. The developer solution is one or more chemicals that convert the latent image on the film to a visible image. Developing agents achieve this conversion by reducing the silver halides, which are pale coloured, into silver metal, which is black. After the film was developed it was similarly treated in a stop bath, which halted the action of the developer. The film was then put through a fixer solution, which makes the image permanent and light resistant by dissolving the remaining silver halide. Finally, the film was washed in water and became a negative suitable for captioning and printing.

The method John Henry Spree used to caption his postcards was to incorporate the caption on the negative. The most common way was to write the caption freehand on the emulsion side of the negative in a dark ink. Most publishers used durable black or red 'Indian' ink, but it did tend to crack over time. Some publishers also used washable ink, which allowed easy recaptioning or amendments. Either way, this method gave white lettering on the finished card. Of course, John Henry had to be careful to write on a section of the negative that was fairly light, so that the caption would show up well on the card.

When photographers wrote the caption on the negative the lettering had to be done backwards, as the light for transferring the negative to a print had to come from the non-emulsion side. This awkward form of captioning was difficult to get the knack of and sometimes letters appeared backwards on the print. I have not yet come across a Spree postcard where there has been such a mistake in the caption.

Finally, the negative was printed onto photographic paper. Silver gelatine photographic papers were available both as POP (printing out paper) and as DOP (developing out paper). Even though the internal chemical structure of both types is very similar, the handling and processing of each was quite different. John Henry Spree would have used both methods of printing at some time during the period that he produced postcards.

Silver gelatine paper improved the quality of paper prints and remained the standard for printing until digital photography became the norm, although it is still available. Before a paper is exposed, the image layer is a clear gelatine matrix holding the light sensitive silver halides, which are typically combinations of silver bromide and silver chloride.

POP photographs are fully developed photogenically using light. The POP photographic paper is placed under a negative into a special copy frame and exposed to daylight or artificial light until the image is developed to the desired image intensity.

DOP silver gelatine photographic paper is exposed only for a short period of time under a negative in a copy frame. The brief exposure to a negative produces a latent image, which is then made visible by a developing agent.

The print is then toned, fixed and washed before being dried. John Henry Spree produced his postcards with a toner to create a sepia colour. Most toners work by replacing the metallic silver in the emulsion with a silver compound, such as silver sulphide, as in the case of sepia toning.

Contact printing was the only realistic method of producing prints until the introduction of the enlarger in the 1920s. Pure silver bromide-coated paper is sensitive and was the type mainly used for printing enlargements in the early days. The first of the modern upright type enlargers was introduced in around 1921. Prior to that they had been solar cameras or horizontal enlargers, which were essentially lantern slide projectors that projected the image from the negative onto photographic paper.

About the Author

Alan Spree BSc CEng MICE MCIHT was born in Nottingham in 1944 and was educated at Glaisdale Bilateral School in Bilborough. He moved to Portsmouth with family in 1959 and completed his secondary education at Eastney Modern School. He took an apprenticeship as a bricklayer in Portsmouth Dockyard and as part of that he received further education at Highbury Technical College. He then gained a degree in Civil Engineering at Portsmouth University before becoming a professionally qualified civil engineer. Alan worked with the Department of Environment at Portsmouth, Reading, London and Germany until voluntary retirement in 1998. He then worked for Berkshire County Council and Preston City Council before retiring in Spain in 2006.